HOW TO DRAW

Buildings

A STEP-BY-STEP GUIDE FOR BEGINNERS WITH 10 PROJECTS

IAN SIDAWAY

NEW
HOLLAND

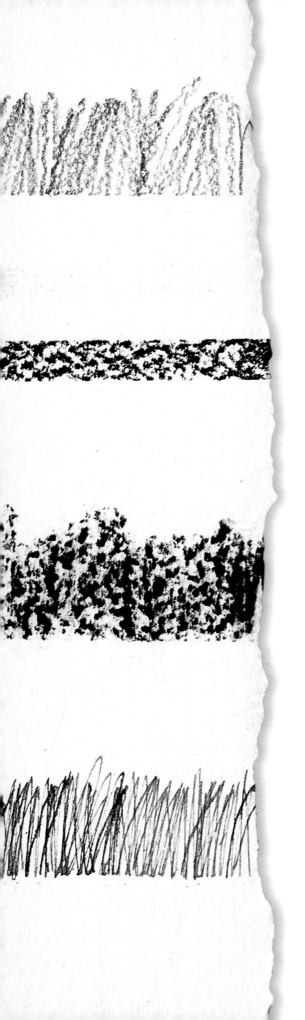

First published in 2004 by
NEW HOLLAND PUBLISHERS (UK) LTD
London • Cape Town • Sydney • Auckland

Garfield House
86–88 Edgware Road
London W2 2EA
www.newhollandpublishers.com

80 McKenzie Street
Cape Town 8001
South Africa

14 Aquatic Drive
Frenchs Forest, NSW 2086
Australia

218 Lake Road
Northcote
Auckland
New Zealand

10 9 8 7 6 5 4 3 2 1

ISBN 1 84330 601 8

Senior Editor: CLARE HUBBARD
Design: BRIDGEWATER BOOK COMPANY
Photography: IAN SIDAWAY
Editorial Direction: ROSEMARY WILKINSON
Production: HAZEL KIRKMAN

Reproduction by Pica Colour Separation, Singapore
Printed and bound by Times Offset (M) Sdn. Bhd., Malaysia

NOTE
Every effort has been made to present clear and accurate
instructions. Therefore, the author and publishers can offer no
guarantee or accept any liability for any injury, illness or damage
which may inadvertently be caused to the user while following
these instructions.

Contents

Introduction

Buildings are familiar to all of us as we spend a great deal of our lives living and working in and around them. Yet despite this apparent familiarity we seldom pay them the attention they deserve and take their presence and function very much for granted.

As a subject for the artist, buildings are often avoided. Firstly, drawing them accurately demands a use of complex perspective, which at first glance is a daunting prospect. Secondly, they are seen as dull, utilitarian and angular, lacking in colour and consisting only of a series of straight lines. However nothing could be further from the truth. Buildings have inspired and provided the subject matter for countless artists of the past. Be it as the main focus that reads as a record of a distinct place and time, for example, in the stunning images of Venice created by Canaletto; or as in the more personal observations of the American Andrew Wyeth, who often uses the vernacular farm buildings in and around his home in Pennsylvania as a form of metaphor for the events which have taken place, and characters who have lived, within them.

Even given a cursory glance it can be seen that the size, shape and style of buildings change from location to location and country to country, to such an extent that they provide an almost limitless and varied source of inspiration. The materials used to create buildings are equally varied, with brick, stone, concrete, wood, glass and steel all used in various combinations, with many older buildings and those in remote or

ABOVE The variety of building types together with the wide range of building materials used provide the artist with limitless possibilities.

so-called third world countries using locally sourced materials collected from and echoing the surrounding landscape. This extensive range of building styles and materials presents the artist with quite a challenge, and calls for the use of a number of exciting artistic techniques and materials in order to convincingly and successfully represent the chosen structure.

Linear perspective, which is approached by many with unnecessary dread, is simply a visual device whereby three-dimensional objects can be convincingly represented on a two-dimensional flat surface. And while its in-depth study can be complex, the basics are surprisingly straightforward and they make the drawing of relatively complex structures and buildings successful even for the beginner.

Using the Book

The 10 demonstrations cover a variety of materials, techniques and building types. The projects become marginally more complex and involved as you progress through the book. The lessons learnt while doing them are cumulative and what is learnt on one can be carried forward to the next, so the absolute beginner may find it better to begin with Demonstration 1 (see pages 18–23).

In addition to the main drawing each demonstration includes an alternative drawing of the same or a similar subject, made using a different drawing material and is there to show further possibilities.

A photograph of an alternative building is also included for you to try out your own treatment and variation without having to find a suitable subject on location.

The treatments for each demonstration are only suggestions. After you have progressed through the book try using dip pen and ink or a ballpoint pen for Demonstration 1 (see pages 18–23) or try a coloured pastel pencil drawing of Demonstration 7 (see pages 54–59). This book is only the starting point. The important thing is to enjoy your drawing while increasing your knowledge of the buildings around you.

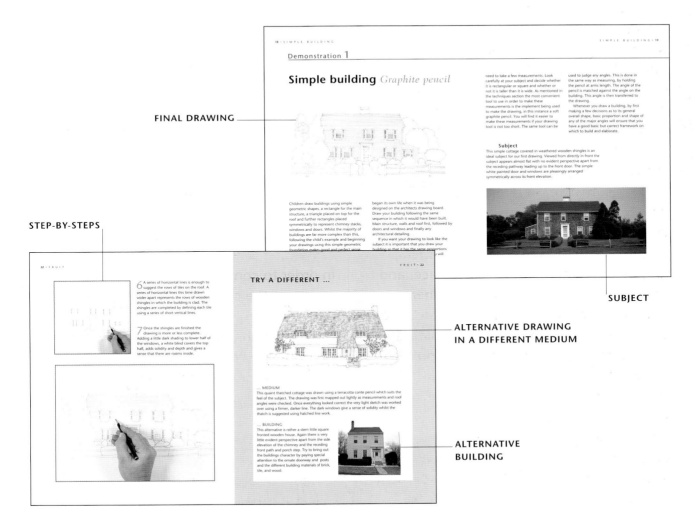

FINAL DRAWING

STEP-BY-STEPS

TRY A DIFFERENT ...

SUBJECT

ALTERNATIVE DRAWING
IN A DIFFERENT MEDIUM

ALTERNATIVE
BUILDING

Tools and Materials

This section describes and explains the materials used in the demonstrations. Use it as a guide when you are purchasing your equipment. Fortunately most drawing materials are relatively inexpensive and capable of producing many drawings before they need to be replaced.

PENCILS The "lead" pencil is familiar to everyone, however it is not and never was made from lead but from graphite, a type of carbon which is mixed with clay and baked. Graphite pencils run from 9H, the hardest – which makes a very pale grey line, down to H and HB – a good all-purpose grade. The grades then run through F (fine) and up through B to 9B the softest – this makes the darkest line of all. Remember that each grade of pencil will give a tone of optimum darkness and applying more pressure will not make that tone any darker. If you require a darker tone then you will need to switch to a softer grade of pencil. Soft pencils will give a greater range of tones than hard pencils. It is for this reason that most drawings are made using a pencil which is HB or softer.

PENCILS

GRAPHITE STICKS Graphite sticks are a popular alternative to traditional pencils. They are made from a thicker graphite strip and lack the wooden casing found in pencils. Available in HB, 3B, 6B and 9B grades, they have several advantages over the orthodox wooden pencil. The barrel shape is round with some brands coated with a thin layer of plastic paint which is removed as the stick is used and sharpened and helps keep the fingers clean. The shape of the stick means that as the stick is sharpened a large area of graphite is always exposed. This makes it possible to create not only fine lines – which can be made into very thick lines by altering the angle at which the stick comes into contact with the support – but also broad areas of flat tone. Shorter, thicker, hexagonal sticks are also available in a similar range of grades, as are smaller rectangular blocks. Both types of stick are best sharpened using a pencil sharpener or by rubbing on fine sandpaper. The resulting powder can be rubbed on to drawings to create areas of tone. Larger quantities of dust can be purchased from art stores.

GRAPHITE
STICKS

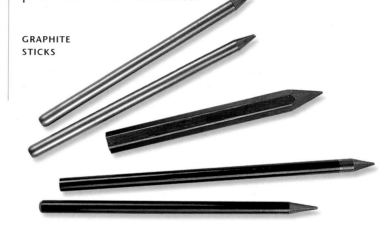

CHARCOAL Made from carbonized wood (usually willow, but beech and vine can also be found), the sticks are graded as soft, medium and hard and thin, medium and thick. Extra thick sticks known as "Scene painters' charcoal" are also available. Compressed charcoal, also known as Siberian charcoal, is much harder and cleaner to use than natural stick charcoal. It is graded by hardness and density and can be found with both round and square profiles. Compressed charcoal is also made into charcoal pencils with either wooden or rolled paper barrels. Sharpen all charcoal by using a sharp utility knife or by rubbing on fine sandpaper. Charcoal dust sits delicately on the support surface and will need fixing to avoid being smudged.

ARTISTS' PENCILS, CARRÉ and CONTÉ STICKS A range of artists' pencils and carré sticks are available in the traditional colours of black, white, sepia, sanguine, terracotta and bistre. Artists' pencils resemble traditional graphite pencils but are also available with a rectangular profile. Carré sticks are solid pigment and square in profile; like the artists' pencils they are best

sharpened using a utility knife. The pencils and the sticks, unlike chalks, have a wax content and so can be used without fixing. Conté chalks are natural pigments bound with gum and are available in a range of colours. Unlike carré sticks these will smudge if rubbed against and can be blended so will need fixing.

COLOURED PENCILS and PASTEL PENCILS Coloured pencils are made in much the same way as graphite pencils. The pigment is mixed with a clay filler and a binder and impregnated with wax. This acts as a lubricant, helping the pencil slide smoothly over the support and fixing the colour to it. Pastel pencils, though similar to coloured pencils, are made from a strip of hard pastel secured in a wooden barrel. The mark is not as permanent as that made with coloured pencils and will need to be fixed. They are easy to work with, the colour is strong and they are perfect not only for finished drawings but for quick sketches and are especially effective when used on a coloured support. Both types of pencil are best sharpened using a sharp utility knife.

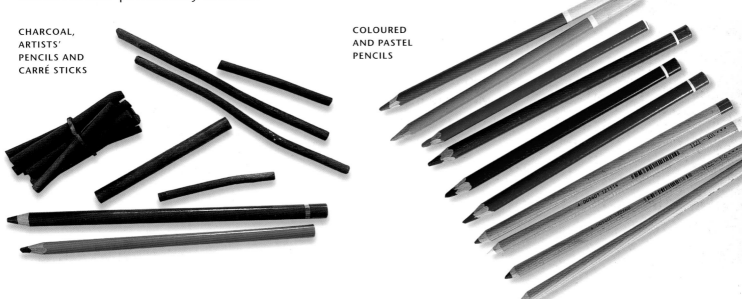

CHARCOAL, ARTISTS' PENCILS AND CARRÉ STICKS

COLOURED AND PASTEL PENCILS

SHARPENERS Pencil sharpeners should be used for graphite sticks but all wooden graphite and coloured pencils are best sharpened using a sharp utility knife. The same is true of conté chalks and carré sticks. Fine sandpaper blocks can be found which are good for keeping the points on graphite sticks in good order.

ERASERS and STUMPS The putty rubber is soft and malleable. It can be used for cleaning up large areas and lightening tone, making textural marks and it can be pulled into a point for putting in highlights. Putty rubbers get very dirty when used with charcoal, soft graphite, chalks and pastel pencils. The answer is to cut the eraser into pieces which, once dirty, can be thrown away. Harder plastic or vinyl erasers pick up less pigment and stay cleaner. They can be used on their edge to make crisp, incised lines in areas of deep tone; alternatively use the sharp corners to make patterns and describe texture. Take care when using erasers not to tear or disturb the support surface. The paper stump, or torchon, is used to manipulate and blend the loose pigment on the drawing, pushing it into, and consolidating it on, the support surface. As the stump point becomes dirty with pigment clean it using sandpaper.

FIXATIVE Drawings made using soft pencil, graphite, charcoal or other soft materials will smudge if rubbed. To prevent this from happening the pigment dust needs to be attached to the support surface using fixative. Bear in mind that once fixed, the drawing cannot be altered by using an eraser. You can, however, work on top of a fixed drawing and it is common practice to fix a drawing periodically whilst it is being made.

INK Drawing inks are either waterproof or non-waterproof. Non-waterproof inks are not as widely available as waterproof inks. Both types of ink can be diluted using clean water but waterproof ink, which is shellac-based, is not soluble with liquid once it is dry. Non-waterproof inks enable the artist to soften line work and even make corrections by lifting out ink using a brush or paper towel. Inks are available in a range of inter-mixable colours.

SHARPENERS, ERASERS
AND STUMPS

INK, BRUSHES
AND DIP PENS

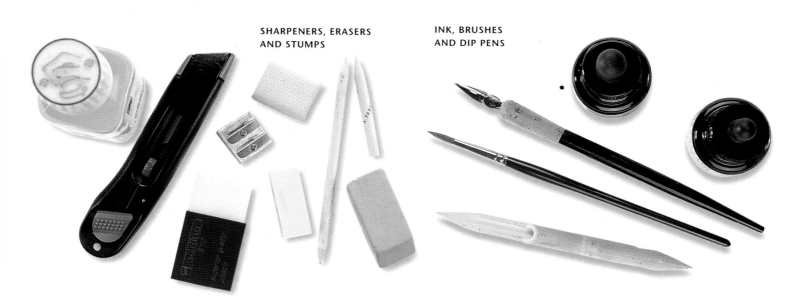

BRUSHES and DIP PENS For applying washes of ink or watercolour good quality sable brushes are best. They hold a large volume of liquid and, if looked after, keep their points well.

Dip pens are available in several shapes. They take interchangeable steel nibs of varying thickness and shape. Certain nibs only fit certain pen barrels, so try before you buy. You may sometimes find that a new nib is reluctant to hold ink, this can be solved by rubbing a little saliva on to the nib. Alternatives to the steel nib are the traditional feather quill, the reed pen and bamboo pen.

ART, BALLPOINT and TECHNICAL PENS
Art, ballpoint, rollerball, fibre-tip, fineliner and technical pens can all be used to make drawings. Hundreds of different types are available and they all have the same single drawback – the size or width of the line they produce is fixed. It is important when using these pens to experiment in order to find what is or is not possible. The pens deliver essentially linear marks and tone is only achieved by the density of the marks being created. This is generally done using some form of hatching or cross-hatching. Some pens however use watersoluble inks making it possible to pull out tone from the line work by working into the drawing using water.

PAPER and SUPPORTS There are three distinct paper surfaces. Rough is, as the name suggests, a paper with a pitted, highly textured, surface. It is best suited to bolder expressive work using charcoal, chalks, pastel pencils and soft graphite. Papers with a very smooth surface are known as "hot pressed" due to the fact that when being made the drying sheet of pulp is passed through hot, steel rollers. These papers are best suited to pen and ink work, wash drawings and fine pencil work. Papers with a medium textured surface are known as "cold pressed" or "NOT"(meaning not hot pressed). Papers in this group happily accept most drawing materials and are perhaps the most widely used types of paper. Tinted drawing papers are available for use with charcoal, pastel and chalks. All of the above papers can be found as loose sheets or bound into sketchbooks. When drawing buildings on location you will find using a sketchbook invaluable.

PAPERS

DRAWING BOARDS and EASELS If you are working on single sheets of paper you will need a drawing board. These are sold in art stores but a good alternative is to use a piece of medium-density fibre-board cut to a suitable size. Use it propped up on a few books. Eventually however, you will need an easel. A good choice for the beginner is either an adjustable table easel or a lightweight sketching easel.

Basic Techniques

This section shows in a simple, straightforward way all of the techniques used in the drawing demonstrations which follow. It explains the results of each technique and which drawing implements are used to make them. It can be beneficial to practise these techniques in isolation without making a drawing so that you become familiar with the particular technique and the results possible. You will also find it helpful if you practise each technique using several different media.

LINE Lines are quick to make and although they do not exist in reality, they are an ideal graphic device for encapsulating and capturing a subject. However, the clever use of line can describe far more than just the shape of something. The most adaptable and expressive drawing materials are those which by varying the thickness or density of the line produced can indicate surface texture or light and shade. These include graphite sticks, charcoal and chalks and dip pen and ink. Less flexible drawing implements include technical pens and ballpoints where the thickness of the line delivered to the support is fixed by the width of the "nib". When using these types of drawing tool the artist needs to be particularly inventive in order to prevent the drawing looking over mechanical and bland.

EXPLOITING THE SHAPE OF THE DRAWING TOOL

EXPLOITING THE SHAPE OF THE DRAWING TOOL It is possible to make a wide range of different marks by varying the angle at which the drawing tool is brought into contact with the support. This is especially true of soft pigmented materials such as charcoal, graphite, pastels and chalks. This is something the beginner often forgets as they produce drawing after drawing while they hold the drawing implement in exactly the same way.

If the drawing implement is suitable try using not only the "point", but turn the tool on its side or edge. Twisting the tool whilst actually making the mark so that more or less of it comes into contact with the support will result in a mark that varies in width. Try experimenting on a sheet of scrap paper to see how many different marks you can make with a single tool. Holding the tool in different ways will help as will moving the drawing tool over the support using the elbow or shoulder rather than the wrist or fingers.

LINE

TEXTURAL MARKS

ERASING

TEXTURAL MARKS Textural marks are important as they are used to describe the different surface characteristics of the subject and the materials it is made from. Textural marks are easier to make when using softer drawing tools such as charcoal or graphite. A range of textural marks are harder to make when using pen and ink, so in order to add variety to your drawing try to be inventive and use a combination of tools such as brushes, sponges and bamboo pens. Variety can also be added by diluting the ink being used. Consideration should always be given to the surface characteristics of the drawing support as this can extend the range and quality of the marks you are trying to make. Care needs to be taken when choosing the support as many buildings are often constructed from a variety of materials, both rough and smooth. Whilst a smooth, hot pressed paper would be ideal for rendering glass it would not be the best choice for an uneven material such as stone.

ERASING Erasers should be used as drawing tools in their own right. Conté chalks, pastel, graphite and charcoal, together with other soft, dusty drawing materials are especially receptive to being worked into using erasers. Textural marks and highlights are often more successful and easier to make when using an eraser to work back into a drawn passage to lift out pigment. Putty erasers work very well with harder graphite but can quickly become dirty and clogged when used with softer materials, resulting in unattractive smearing. Hard plastic erasers are good for making sharp, distinct marks and fine lines. Soap gum erasers are used for cleaning up large areas; a similar result can be achieved by rubbing soft white bread onto the support. In order to keep your erasers clean cut pieces off which can be discarded once dirty. Rubber erasers are efficient but use only those that are coloured white. Take care when using any eraser not to tear or distress the surface of the drawing support.

TONE/SCRIBBLING

TONE/HATCHING

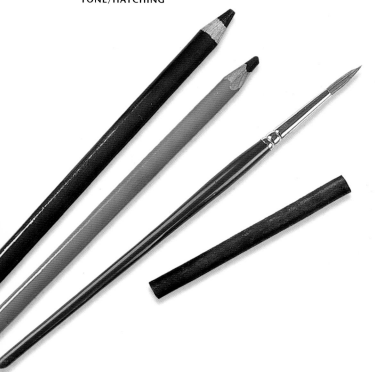

TONE Tone describes the lightness or darkness of something and in so doing also helps to describe its form. Without tone everything would appear as a flat shape. Applying tone is sometimes referred to as shading, which is something of a misnomer. The amount and direction of light falling on your subject and the subject's actual colour will affect the tones you see. Tone can be applied in several ways. The first is by scribbling which is both fast and efficient. It is also easily controllable and with a little practise it is possible to quickly cover an area with uniform tone or apply graded tones which run from pale grey to dense black. When applying scribbled tone vary the direction of the strokes to ensure they do not build up all running in one direction. Increasing the pressure applied to the drawing instrument increases the depth and density of the tone achieved. For extra control when applying dark tone hold the drawing implement near to its point; when applying lighter tones hold the implement higher up the shaft.

The second way of shading is known as hatching, this is a method of applying tone using a series of parallel lines. It is essentially a linear technique which can be used with all drawing media but comes into its own when used with pen and ink or technical pens and ballpoints which deliver a line of a consistent width. Depth or density of tone is achieved by placing the lines closer together. Cross hatching uses blocks of hatched lines set at an angle to each other.

Pigment applied using soft, dusty drawing materials like charcoal, soft graphite, pastel and chalk can be manipulated by smudging or rubbing with the finger, a paper towel or

a torchon or paper stump which is made for just this purpose. This is known as blending. Blending is a useful and fast technique, which can be combined with other techniques. However, if overdone it can make for a bland, "soft focus" drawing that lacks any real bite. Combining blended tone with contrasting sharp focus line work can be particularly effective.

Stippled tone can be made with all drawing media. Tone is built up by varying the size and density of the stippled marks. These marks consist of dots, dashes and ticks. These are stippled rapidly onto the support by tapping and jabbing the drawing tool by using the wrist and elbow. When using pen and ink, or even pencil this technique can be slow, but it is considerably faster with pastel, charcoal and soft graphite stick. The technique does not have to be used in isolation but is better combined with other "shading" and line techniques. It is particularly effective when depicting brick and stone work.

Achieving tone when using ink or watercolour is done in exactly the same way. The colours are mixed or thinned using water to create thin, tonal washes. The more water added, the "thinner" or lighter in tone the wash. These washes can be built up one over the other – "wet on dry", by allowing each to dry before applying the next, or worked "wet into wet". Washes often dry lighter than they look when wet and it may help to test any washes before applying them to a drawing. Think hard when judging the tone of washes. Remember it is easy to darken a wash by applying another wash over the top, but it is difficult to lighten a wash once it has been laid.

TONE/SMUDGING/BLENDING

TONE/STIPPLING

TONE/WASH

COMPOSITION – IMAGE POSITIONED IN UPPER VERTICAL THIRD.

COMPOSITION – IMAGE DRAWN IN MIDDLE THIRD.

MEASURING AND PROPORTION In order to get proportion and angles correct, artists use a measuring system. This is usually made using the drawing implement being used. In order to take a measurement hold your pencil out at arm's length so that it is aligned with the part of the subject being measured. Position the top of the pencil against one end of the part to be measured then slide the thumb up or down the shaft of the pencil until it rests in line with the other end of the part to be measured. This unit is then transferred to the drawing. This same unit can be used to compare the size and position of other parts of the subject and the results plotted on your drawing in relationship to each other. It may sound complicated but in reality it becomes second nature, and once a few measurements have been made the rest of the drawing can be related to them.

A grid is also helpful when plotting out a drawing and assessing proportions accurately. A simple grid can be easily made by cutting a rectangle from the centre of a piece of thick card. Over this stretch thin elastic bands to form your grid. This grid can

consist of as many verticals and horizontals as you wish, but three or four should suffice. Lightly draw an identical grid onto your support. These can be any size as long as they are in proportion to the grid made using the piece of card. Hold the card grid up and look through it at your subject then quickly plot out the position of what you see onto the drawing using the grid lines you drew earlier as a guide. It will be impossible to draw in all of the details using this method but it will allow you to judge the relative position of things.

COMPOSITION The way in which all of the elements are arranged within the picture area is known as composition. A drawing that is well composed should be balanced and pleasing to look at, with the positioning and use of the pictorial elements pulling the eye into and around the work. Many elements need to be considered when planning the composition. Colour, scale, space, form and texture are all strong compositional elements and need attention. In order to achieve this visual harmony

COMPOSITION – IMAGE POSITIONED IN LOWER THIRD.

several formulae have been devised which divide the picture area up into an invisible grid onto which the main elements of the work can be positioned. Perhaps the most well known, but by no means the easiest to understand or work out, is the "Golden Section". This is based on the principle that an area can be divided in such a way so that the "smaller part is to the larger, as the larger part is to the whole". One of the simplest and most adaptable is the so called "rule of thirds". This requires the picture area to be divided into thirds using a grid of horizontal and vertical lines. The important elements of the subject are then positioned on or about these lines or at the point they intersect, as in the four illustrations seen here.

The card grid made for checking proportion can also be used for checking composition. Simply stretch two elastic bands across the cut rectangle at equal distances horizontally and two at equal distances vertically. This can then be held, as before, at arm's length and the proposed composition of the subject viewed through it.

This device will also enable you to check whether the subject will work best using a portrait format, with the longest side of the rectangle running vertically or as a landscape format, with the longest side of the rectangle running horizontally. When working out a composition it can be helpful to make a series of small sketches known as thumbnails. These provide not only useful drawing practise but a means by which various compositions can be compared. Whilst good composition is important, rules are made to be broken and with practise you may find that taking risks with your compositions results in drawings that have a certain seductive tension and edge.

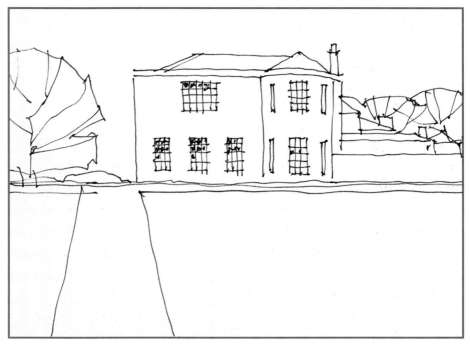

THE PATHWAY IN THE FIRST VERTICAL THIRD DRAWS THE EYE UP INTO THE PICTURE.

PERSPECTIVE Linear perspective is a system that was devised during the Italian Renaissance whereby three-dimensional reality is made to read convincingly on a two-dimensional flat surface. The laws of perspective dictate that all parallel lines on any flat surface or plane, other than a surface seen straight on, eventually meet at a point in space known as the vanishing point (VP). The vanishing point is on the horizon line that runs horizontally at eye-level across your field of vision. Regardless of your position, if you are sitting down or standing on the top floor of a ten storey building, the horizon line will still run across the field of view at your eye-level. All receding parallel lines below the horizon line run up to meet at their vanishing point and all receding parallel lines above the horizon line run down to their vanishing point. Establishing the VP is important as it provides the beginning of a framework upon which the drawing of the building is constructed.

Once extended, if all of the receding parallel lines to the eye-level or horizon line meet at a single vanishing point it is known as one- or single-point perspective. This type of perspective is typical when only one side of a building can be seen at an angle. However in the real world we tend to see two sides of a building both running at an angle away from us. In this case there will be two vanishing points as any parallel lines on both sides of the building are extended until they meet on the horizon line. This is known as two-point perspective.

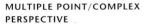

MULTIPLE POINT/COMPLEX PERSPECTIVE

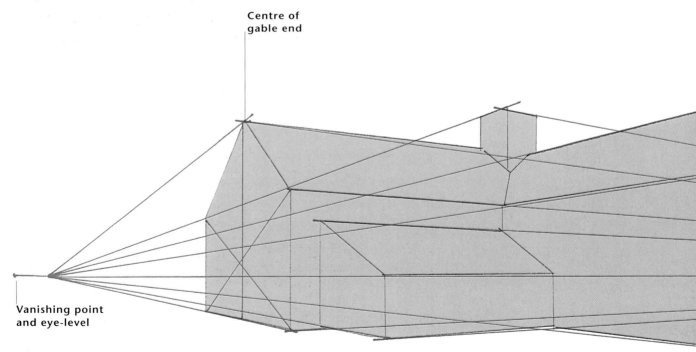

Centre of gable end

Vanishing point and eye-level

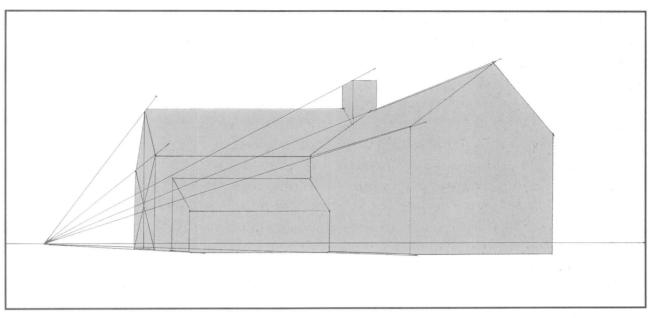

LINEAR PERSPECTIVE

If, however, there are several buildings all positioned at different angles each will have its own vanishing points. This is known as multiple point or complex perspective. Whilst this may at first sound tricky, by beginning to make drawings using simple perspective the rules will become clear and it will not be long before you tackle more challenging drawings with confidence.

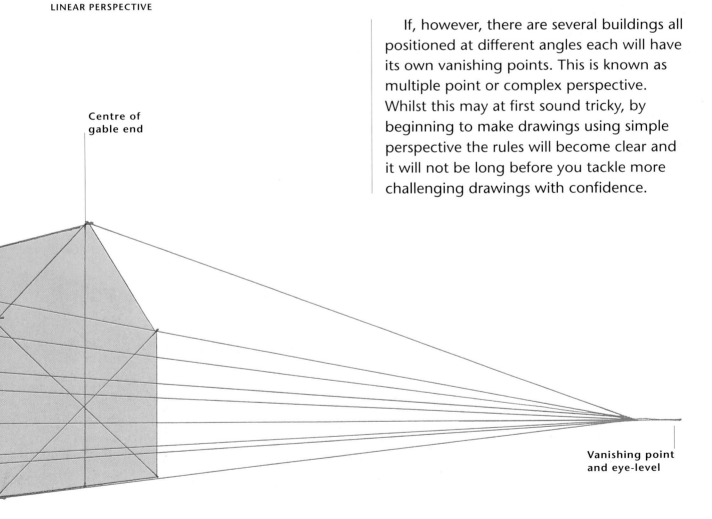

Centre of gable end

Vanishing point and eye-level

Demonstration 1

Simple building *Graphite pencil*

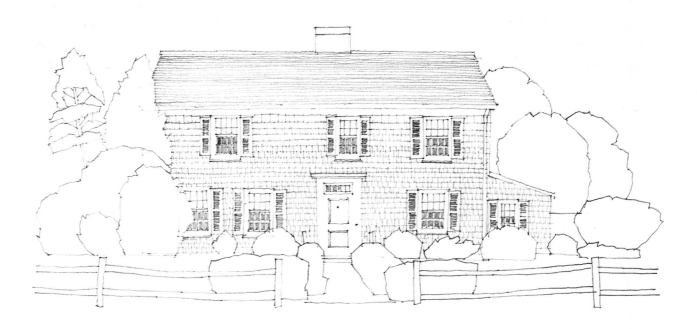

Children draw buildings using simple geometric shapes – a rectangle for the main structure, a triangle placed on top for the roof and further rectangles placed symmetrically to represent chimney stacks, windows and doors. Whilst the majority of buildings are far more complex than this, following the child's example and beginning your drawings using this simple geometric foundation makes perfect sense. For it is in exactly this way that the building began its own life when it was being designed on the architect's drawing board. Draw your building following the same sequence in which it would have been built. Main structure – walls and roof first – followed by doors and windows and finally any architectural detailing.

If you want your drawing to look like the subject it is important that you draw your building so that it has the same proportions as the original. In order to do

this you will need to take a few measurements. Look carefully at your subject and decide whether it is rectangular or square and whether or not it is taller than it is wide. The most convenient tool to use in order to make these measurements is the drawing implement, in this instance a soft graphite pencil. You will find it easier to make these measurements if your drawing tool is not too short. The same tool can be used to judge any angles. This is done in the same way as measuring, by holding the pencil at arm's length. The angle of the pencil is matched against the angle on the building. This angle is then transferred to the drawing.

Whenever you draw a building, first make a few decisions as to its general overall shape, basic proportion and the shape of any of the major angles to ensure that you have a basic but correct framework on which to build and elaborate.

Subject

This simple cottage covered in weathered wooden shingles is an ideal subject for our first drawing. Viewed from directly in front, the subject appears almost flat with no evident perspective apart from the receding pathway leading up to the front door. The simple white painted door and windows are pleasingly arranged across its front elevation.

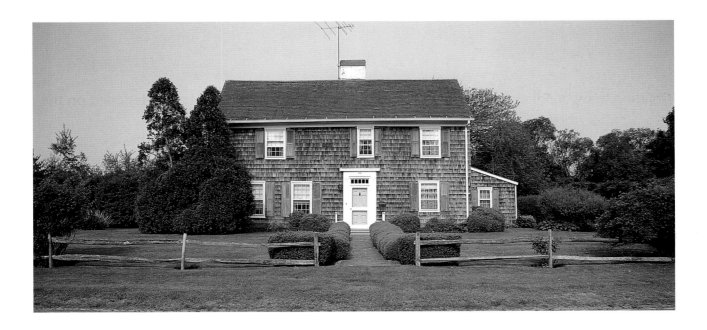

Materials

2B graphite pencil

*Sheet of white cartridge (drawing) paper
594 x 420mm (23½ x 16½in)*

1 The size and shape of the building's front elevation is made by using the pencil to measure the height from the floor to the eaves of the roof. Draw a line corresponding to this unit of measurement to represent one end of the building. Use the same unit of measurement to judge the length of the building, which is just over two units of measurement. Drawing a line at this point positions the other end of the building. Draw a line top and bottom to join these to give a rectangle of the correct proportion for the building. The roof of the small lean-to joins the main building just over halfway up. Assess the angle of the roof with the pencil and draw this in. Judge the drop of the roof line and draw in the vertical to give the very end of the building's front elevation.

2 The position and proportion of everything else you draw connected to this building will be related to these first six lines. If you measure the width of the lean-to you will see that it is almost the same as the distance from the roof guttering up to the ridge. The chimney is positioned just to the right of centre, immediately above the door. Finally judge the relative position and size of the window frames and draw them in as simple rectangles.

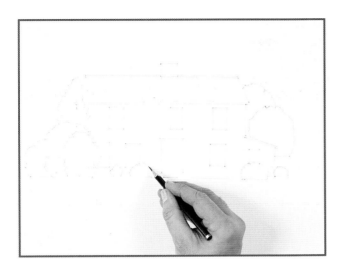

3 You can now begin to position the building in its environment. Draw in the trees positioned to the left; notice how they fall across the front of the building. The trees on the right are further back and well behind the building. Now draw in the small mounds of shrubbery arranged across the base of the building below the windows.

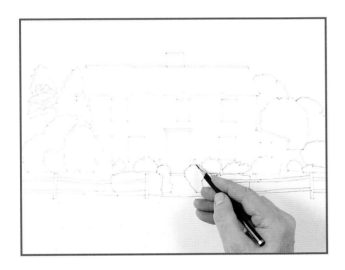

4 Complete the trees and shrubbery by adding further trees left and right. A low, simple wooden fence runs across the front of the building with a gap to give access to the path leading to the front door. The angles of the hedgerows on either side of the pathway as they run back to the front door are the only traces of perspective to be seen and have the effect of flattening out the foreground making it appear to run towards the viewer, away from the house.

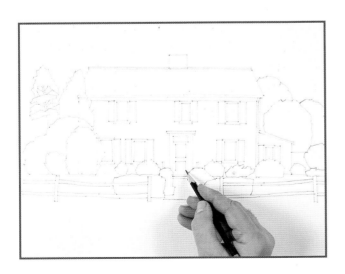

5 It is now time to turn our attention to the detail on and around the doors and windows. Firstly draw in the inside edge of the window frames, followed by the glazing bars. Try to position these carefully so that the individual "panes of glass" are correctly proportioned.

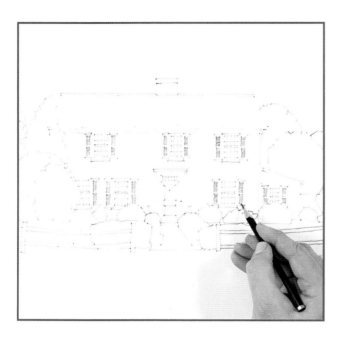

6 Draw in the detail and moulding on the front door and the small row of windows above. Sketch in a series of lines to represent the opening in the window shutters.

7 A series of horizontal lines is enough to suggest the rows of tiles on the roof. A series of horizontal lines, this time drawn wider apart represents the rows of wooden shingles in which the building is clad. Complete the shingles by defining each tile using a series of short, vertical lines. Add a little dark shading to the lower half of the windows to add solidity and depth and give a sense that there are rooms inside.

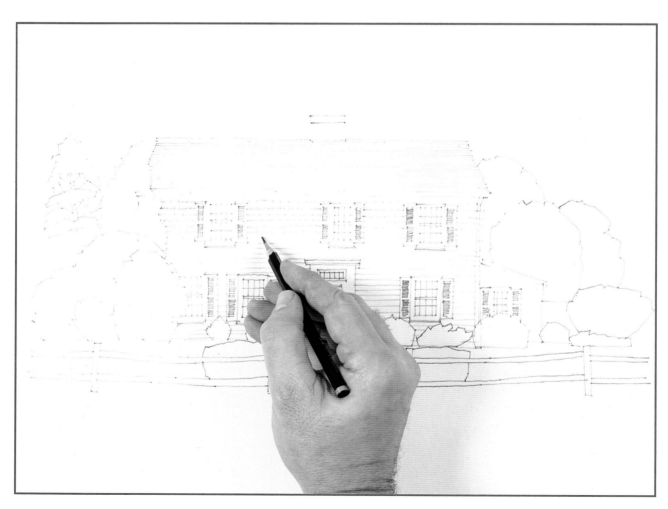

TRY A DIFFERENT ...

... MEDIUM

This quaint thatched cottage was drawn using a terracotta conté pencil which suits the feel of the subject. The drawing was first mapped out lightly as measurements and roof angles were checked. Once everything looked correct the very light sketch was worked over using a firmer, darker line. The dark windows give a sense of solidity, whilst the thatch is suggested using hatched line work.

... BUILDING

This alternative is rather a stern little square fronted wooden house. Again there is very little evident perspective apart from the side elevation of the chimney and the receding front path and porch step. Try to bring out the building's character by paying special attention to the ornate doorway and posts and the different building materials of brick, tile and wood.

Demonstration 2

Introducing perspective
Graphite stick

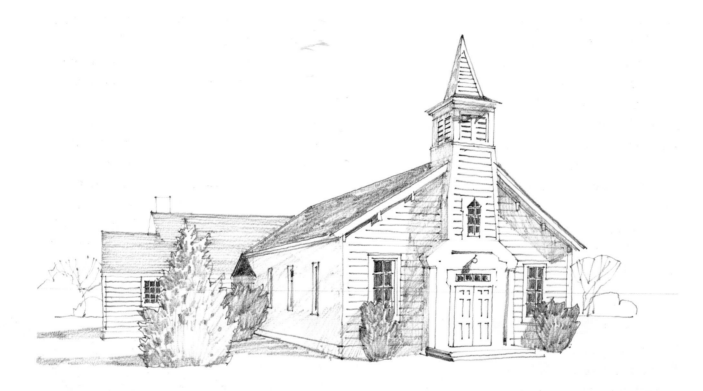

In order to create the illusion of three-dimensional reality on a two-dimensional surface, the artist uses a device known as linear perspective (see pages 16–17). Many view perspective with trepidation and see it as a complex subject that, if possible, is best avoided. Whilst it is certainly true that perspective can be complex, the rudiments of simple perspective are very straightforward and surprisingly easy to master. Besides, if you are drawing buildings it will be difficult to avoid. You will soon find that having a basic grasp of the rudimentary rules will enable you to draw buildings that appear solid, relate to one another and stand convincingly in their surroundings. The

purpose of the perspective system is to illustrate how there is an apparent and relative decrease in size of any object or objects the further away they are from the viewer.

Put simply, the system dictates that any set of parallel lines seen on a receding plane converge at a point in space known as the vanishing point. This point is on the horizon line, which is also known as the eye-level. The horizon line is an imaginary line that runs horizontally across the field of view, this is always at eye-level regardless of whether you are sitting, standing or positioned at the top of a 20-storey building. All perspective lines above your eye-level will appear to travel downwards to meet their vanishing point, whilst all perspective lines below the eye-level will appear to travel upwards to meet their vanishing point.

If all of these imaginary perspective lines meet at a single vanishing point it is known as single- or one-point perspective. This type of perspective can be seen when looking down a street with terraced houses on either side.

If perspective lines meet at two vanishing points then it is known as two-point perspective. This is the type of perspective you will see if standing at the corner of a building so that you can see two sides of it as they angle away from you. If there are more than two vanishing points then it is known as multiple point or complex perspective. This type of perspective can be seen when several buildings are built close to each other but are at different angles and heights, such as when buildings cover a hillside or slope.

Subject

This white-painted, weather boarded church offers the perfect subject to illustrate the principles of two-point perspective. Seen from one corner perspective lines meet at two vanishing points. Those for the side elevation meet well within the picture area on the left, while those for the front elevation converge further off to the right at a spot well outside the picture area.

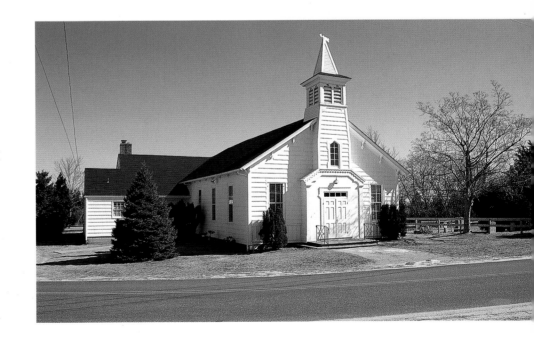

Materials

3B graphite stick

Sheet of white cartridge (drawing) paper 594 x 420mm (23 1/2 x 16 1/2in)

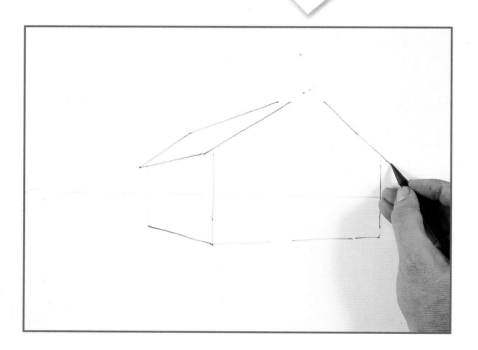

1 Begin by drawing a horizontal line all of the way across the picture area to establish the eye-level. Measure the height of the corner vertical and draw this in. Notice how the eye-level runs through this line almost exactly at the halfway point. Judge the angle of the wall at the point it meets the ground and transfer this to the drawing. Take a measurement and gauge the distance along this line to the back corner vertical and draw this in. Again notice how the eye level bisects this line at the halfway point. Joining the top of the two verticals gives the roof line at the eaves. Both of the angled lines, if extended, will meet at a vanishing point on the eye-level on the left. Carefully assess the angle and height of the roof and draw this in. The ridge line, if extended, should run down to the existing vanishing point. Measure across the front of the church and position the right-hand front corner vertical. Establish the ground level; if extended this would meet the eye-level and establish a second vanishing point outside the right-hand side of the picture area. Draw in the right-hand roof pitch.

2 Next draw the spire. Extend any lines which run parallel to those already drawn down to the existing two vanishing points. Notice how the lower portion of the spire splays out at an angle where it is attached to the front of the building and the roof. The buildings attached to the rear of the church – although at the same angle as the main building – appear to be seen almost end on with little or no apparent perspective except where the end wall can be seen below the roof line.

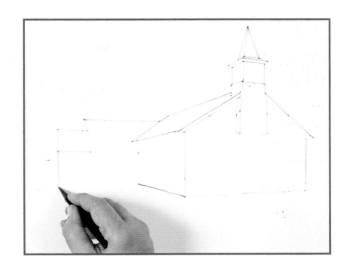

3 Modify the timbers supporting the eaves and draw in the chimney stack on the rear building. To prevent the building from looking like it is floating in mid-air, firmly position it in its environment by drawing in the surrounding shrubbery and trees. Draw in a horizontal ground level line either side of the building. It should be lower than the horizon or eye-level.

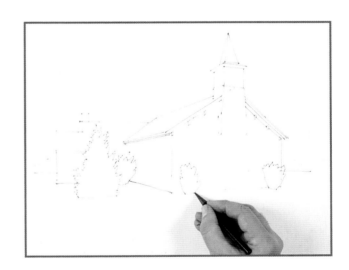

4 Four vertical lines show the edge of the shuttered ventilation openings on the front and side of the spire. Continue the base of the spire down to form the slightly protruding doorway. Draw in the front steps. Run the lines which indicate the front and side of these back to the two vanishing points. Draw in the small window above the front door and the door itself. Finally, draw in the window frames taking care to draw them in perspective using the other elements on each side of the building as a guide.

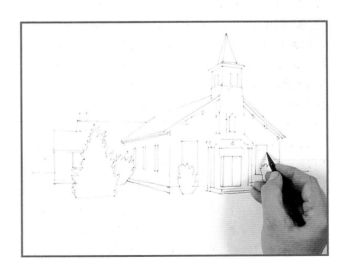

5 Draw in the ventilation slits at the top of the tower, the moulding details on the front door, the internal window frame and the window glazing bars. The building's true character now begins to be more apparent. Draw a series of parallel lines to represent the weather boarding on the rear building. Draw a similar series of lines on the tower and the front elevation, with each line drawn so that if extended they would converge at the vanishing point way off to the right.

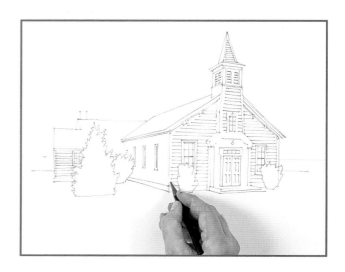

Artist's tip
Vanishing points often appear a long way outside the edge of the support. These points and the perspective lines running to them can be plotted on an extra sheet of paper attached to either side of the drawing. These are removed once the drawing is finished.

6 Draw close lines on the rear building to show the roof covering. Scribble a dark tone across the main roof and beneath the eaves. Apply a lighter tone where the roof line casts a shadow across the front of the building and down the side of the spire. Apply a similar tone to the side of the building. Complete the drawing by applying a little linear detail to the trees in the far distance. Apply tone to the trees and shrubbery at the base of the building. Finally apply a dark tone into each of the small windows. This final act instantly seems to bring the building to life.

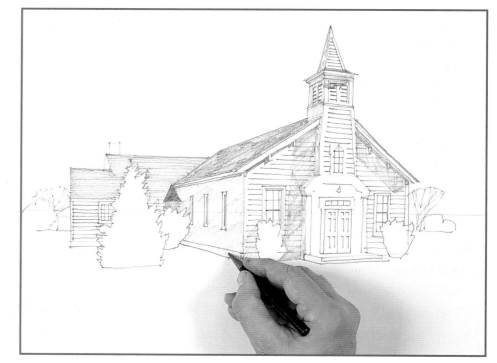

TRY A DIFFERENT ...

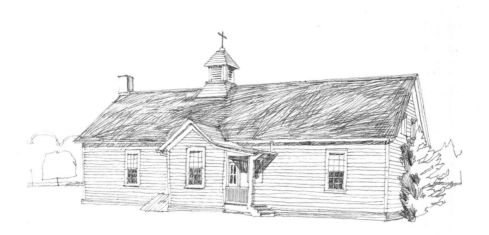

... MEDIUM

A black ballpoint pen was used to sketch this little schoolhouse or chapel that is constructed in much the same way as the building in our demonstration. The ballpoint delivers a line of standard width and quality, which can be difficult to vary, unlike the line made by graphite which can be made to alter in thickness and tone. Applying more pressure to the ballpoint will make a darker line whilst working fast can result in a slightly lighter line. Tone is made by making marks which are densely packed together.

... BUILDING

Our alternative building is seen from the front and perfectly illustrates single-point perspective. If the two edges of the pathway are extended they join at the centre of the front door. If you draw this building by extending the receding side edges of each storey of the spire – even though the angles seem extreme – down to the same vanishing point, the building will appear correct.

Demonstration 3

Introducing colour
Pastel pencils

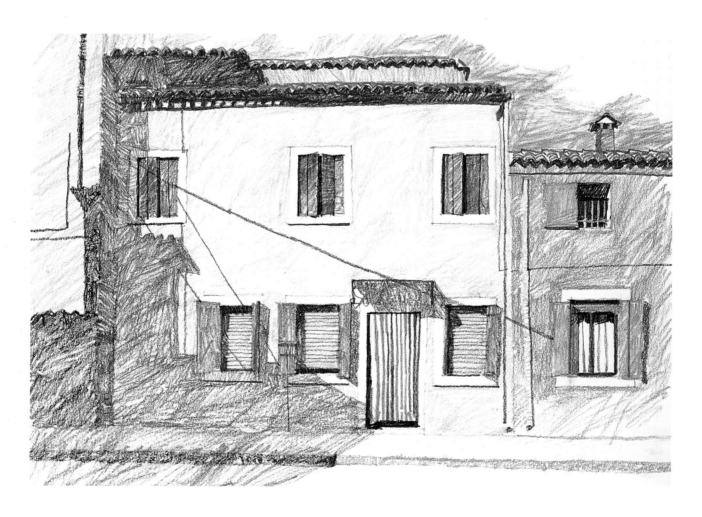

Colour is an important part of our surroundings and it can play a crucial role in describing a building's character and type. Red brick, grey or ochre stone, silver weathered woodwork, pink painted stucco and painted timber all conjure up certain building types which are associated with specific geographical areas and places. A common mistake with beginners when starting to use colour, is to use it in such a way as to "fill in" a line drawing that has been drawn previously, often using a

standard dark, unsympathetic pencil line. This should be avoided at all costs. Coloured drawing materials need to be chosen and used with care. The coloured drawing materials used in this book have two distinct things in common: one, they are all dry materials and two, the colours are mixed and merged on the drawing surface, unlike liquid materials such as paint, which can be mixed on the support surface but are invariably mixed on a palette first, before being applied. Pastel pencils work well even on a relatively smooth surface, such as the drawing paper used here. When applying areas of colour try to keep the work "open" and allow some of the support surface to show through. This achieves two things: firstly, it prevents the image from looking too dense and overworked; secondly, it enables subsequently applied colours to mix better optically rather than just looking dull. This effect is even more evident and pronounced when coloured drawings are made using a coloured or tinted support. We will do this in a later project (see Demonstration 7, pages 54–59).

Subject

These colourful cottages in an Italian fishing community cry out to be drawn using colour. Each house is painted in a different bright colour and, although far from subtle, the overall effect is charming and uplifting, even when seen in the dullest of stormy weather.

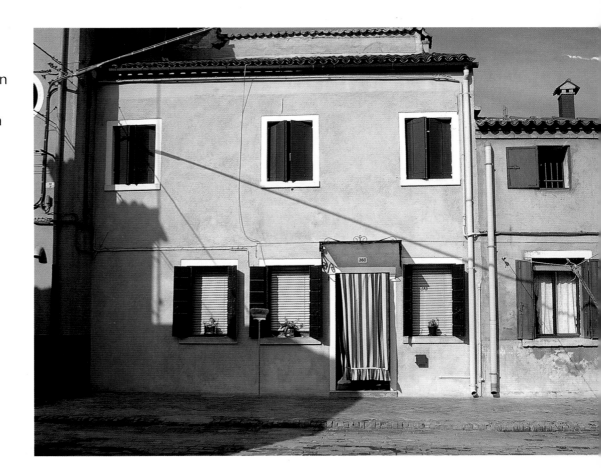

Materials

*Light cerulean blue,
warm grey, terracotta,
sap green, viridian green,
ultramarine blue, cobalt
blue, yellow ochre, dark
blue-grey, burnt umber and
black pastel pencils*

*Sheet of white cartridge (drawing)
paper 594 x 420mm (23½ x 16½in)*

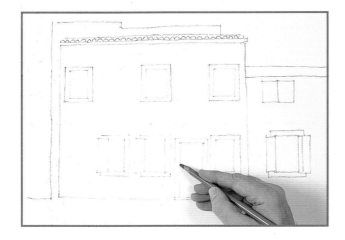

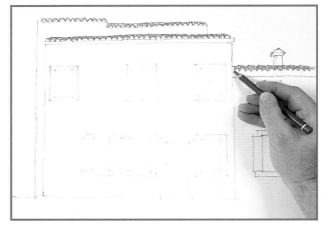

1 Using the light cerulean blue pencil measure the height and width of the front elevation and transfer these measurements to the drawing to create a simple, slightly off-square, rectangle. Once the proportion of this rectangle is correctly positioned it is relatively straightforward to relate all the other elements to it. Draw the window surrounds next. Change to a warm grey pencil and draw in the position of the buildings either side of the featured building, the roof line and tiles and the window and door apertures.

2 Next use the terracotta pastel pencil to draw in the rows of terracotta roof tiles. Notice how the ridge tiles are laid lengthways. The tiles are drawn in using line alone; the white paper is allowed to show through to represent the light reflecting off the tile surfaces. Draw the chimney on the right using the same pencil.

3 Use the ultramarine pencil to draw in the head of the blue plastic broom leaning against the shutter and terracotta for the broom handle. The painted wooden window shutters are dark viridian green, as is some of the linear pattern on the blind flapping across the front door. Use the sap green pencil to draw in the rest of the pattern along with the shutters on the right-hand building.

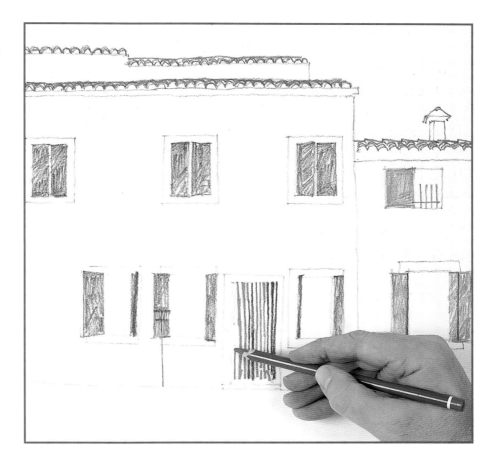

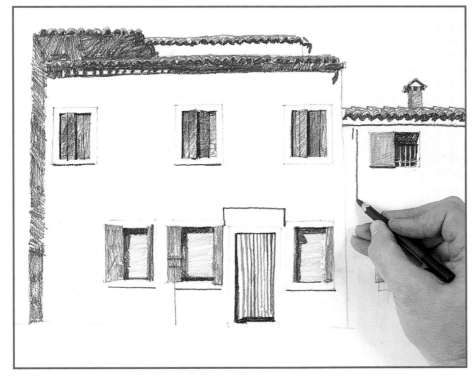

4 Draw the blinds inside the lower floor windows using yellow ochre and the shadows cast across them using burnt umber. Create the deep shadow cast by the building on the left and the shadows beneath the roof overhang and in the windows with dark grey. Reinforce the darkest of these shadows with black.

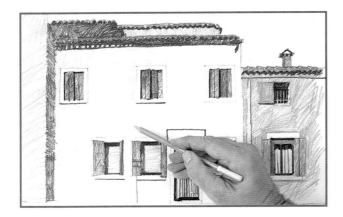

6 Shadows from buildings outside the picture area are thrown onto the left hand building. Draw them in using the black pencil. Shadows from the tall building on the left and various cables strung between the buildings are cast across the featured building. Draw these using a dark blue-grey. Use the same colour for the shadow cast by the shutters and the awning above the door. Complete the drawing by marking in the linear pattern on the ochre sun shades using the burnt umber pencil. Use the same colour to scribble in the warm shadow cast across the foreground. Finally, use black to create the kerb edge in shadow, warm grey where it continues into the sunlight and a cobalt blue for the sky.

5 The overall colour of the building seen to the left of the featured building should be drawn using yellow ochre. Then establish the colour of the building on the right using the light, warm grey. Use the same colour for the wall of the building seen above and behind the main building. Use light cerulean blue on the wall of the central building.

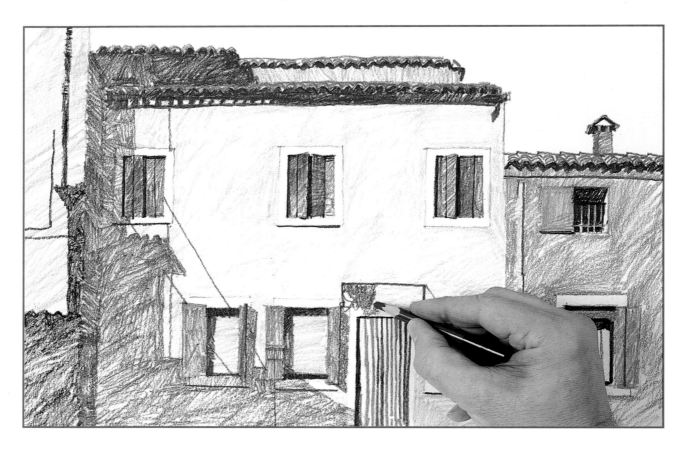

TRY A DIFFERENT ...

... MEDIUM

A medium charcoal pencil has been used to draw this scene which is located close to the building drawn in the featured project. Colour can give clues as to the location of a building and the materials it is made out of. Here it is the washing hung in front that provides clues and enlightens us as to the possible occupants of the building.

... BUILDING

This building is in the same village as those buildings used in the demonstration and the alternative drawing and is very much a variation on the theme. It provides not only the opportunity to use colour but to practise the one-point perspective talked about in Demonstration 2 (see pages 24–29).

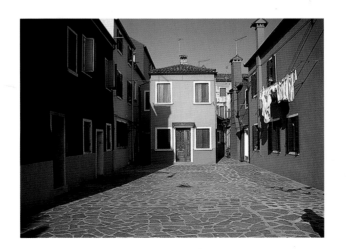

Demonstration 4

Architectural detail
Charcoal and pastel pencils

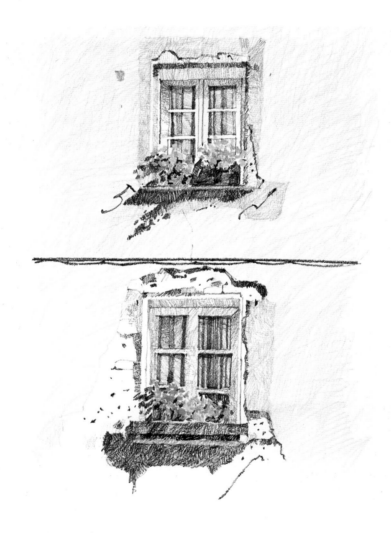

Much of a building's distinctiveness and special character shows through in its architectural detail and the materials it is constructed from, rather than its overall shape and proportion. Buildings are often built using easily found local materials. Stone, brick and wood for walls, slate and terracotta tile for roof coverings, and wood

and carved stone for windows and doors. These are often shaped in very distinct ways as are the shape and number of the doors and windows, and their position and placement within the general structure. The size, style and placement of doors and windows also indicate the age of a building, the social standing of its original occupants and the building's original function. When drawing a building, careful observation and representation of these characteristics are as important as the careful observation of the overall shape and proportion. Indeed, many artists choose to base their drawings solely on these elements and details and ignore the overall shape of the building altogether. Focusing in on these details also enables the artist to make more of the surface textures that are often more evident and pronounced on the crumbling façade of many older buildings. Exploiting these details presents the artist with a whole new range of creative and aesthetic possibilities and gives an opportunity to practise texture-making techniques. Get into the habit of carrying a small sketchbook, as while it might not be possible to make complete drawings, making small sketches and notes of architectural details is unobtrusive, takes precious little time and will provide useful drawing practice.

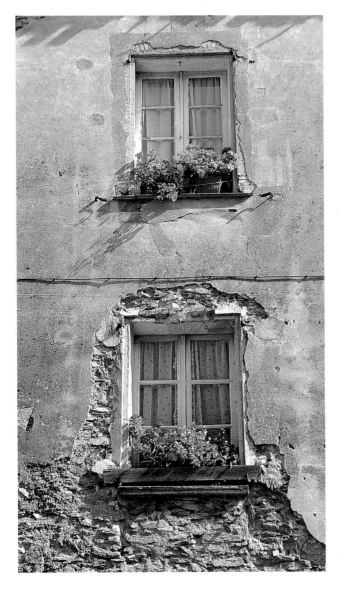

Subject

The distressed and pitted plaster and brick-work surrounding the upper storey windows of this pretty, unassuming, terraced village house in southern France pay testament to its age and the hot, dry conditions of the area. The delicate and colourful pots of geraniums provide a strong contrast with the grey and ochre stonework.

Materials

Black charcoal pencil

*Flesh colour, pink,
cadmium red, crimson red,
olive green, dark grey,
light blue, burnt sienna,
burnt umber, yellow ochre,
dark blue-grey pastel pencils*

*Sheet of white cartridge (drawing) paper
594 x 420mm (23½ x 16½in)*

1 Use a black charcoal pencil to draw in the two windows. Pay attention to the proportion of the window aperture and each of the individual panes of glass. Consider the distance from the top of the lower window to the bottom of the upper window.

Imagine an adult standing and looking out of each window to help you to visualize the internal position of the floors and ceilings and the height of the rooms within. Begin to suggest the shadow areas beneath each window and around the crumbling plaster.

2 Draw in the pink geraniums in the upper window using pink and flesh colour. Draw in the red geranium flowers in the lower window in the same way. Scribble in the foliage using an olive green.

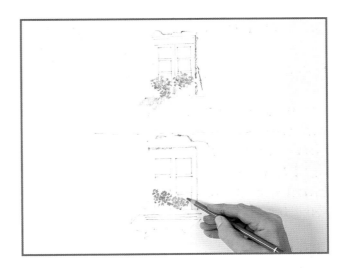

Artist's tip
Keep your coloured pencils sharper for longer by constantly turning them as you work. This has the effect of maintaining the point and makes it easier to make precise, crisp marks.

3 Strengthen the shadow beneath the top window using a dark grey. Use the same grey to draw the deep shadows in and around the pink geraniums and the shadows made by the folds in the net curtains covering both windows. Lightly scribble over the glass in light blue to hint at the light reflecting off its surface.

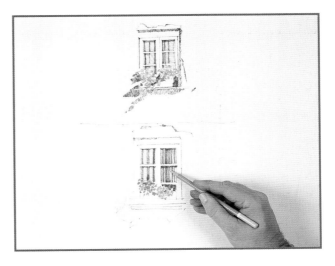

4 Use burnt sienna to draw in the flower pot in the upper window before changing to burnt umber pencil to scribble in the shadow colour on the window frames. On the surrounding plasterwork and the window sills use yellow ochre. Deepen the dark shadows within the windows using the dark grey.

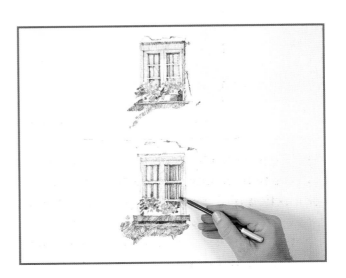

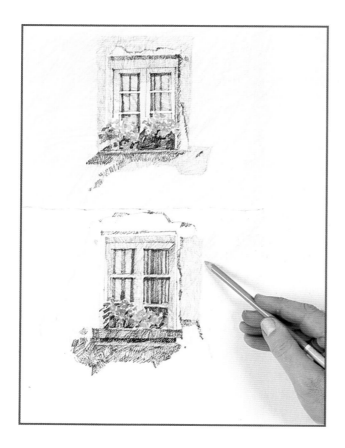

6 Consolidate the overall colour of the window frames using burnt umber. Deepen the shadows cast by the plants and the ledge beneath each window using a dark blue-grey pencil. Use the same grey to deepen the colour in the glass. Draw in the wire running horizontally across the wall followed by the deep shadows cast by the broken and pitted plaster and stonework using the black charcoal pencil. Complete the drawing by carefully defining some of the exposed stonework, revealed by the crumbling plasterwork, using the burnt sienna and burnt umber pencils. Finally, use the black charcoal pencil to draw in some crisp shadow detail.

5 Apply the ochre pastel pencil to the darker plaster area immediately surrounding the window opening. This area was probably an attempt to repair the crumbling plaster at some point in the past. Use the same colour for the overall wall colour, but apply less pressure to create a lighter tone.

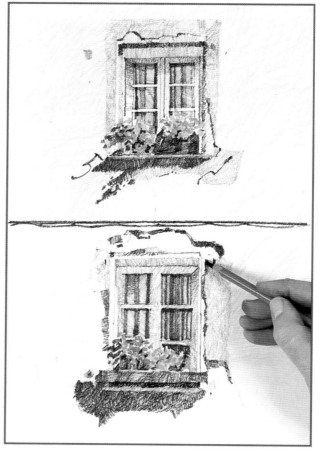

TRY A DIFFERENT ...

... MEDIUM

Although a similar subject, this window has been drawn using a completely different treatment. A light sketch in pencil provided a guide over which line work and cross-hatching has carved the image out of the white paper using a technical pen with a fine standard width nib. Tone has been built using line density alone.

... BUILDING

Another variation on the theme, a little human interest is added to this view with the addition of a few articles of washing. Peeling and worn paint replace weathered stonework. This subject might benefit from a smoother, less textural approach, with colours being blended with a finger or torchon.

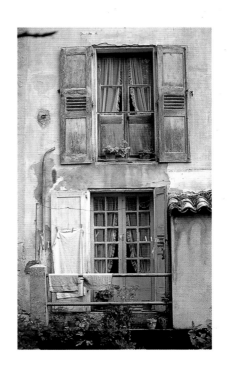

Demonstration 5

Cityscape *Charcoal pencils*

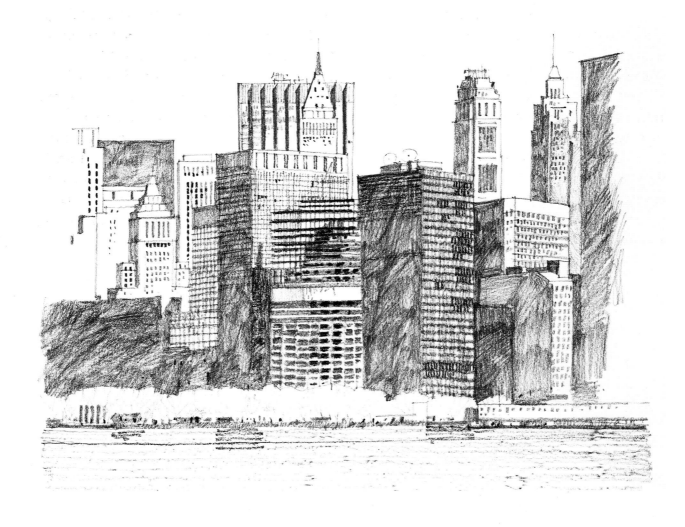

Like it or not, many of us spend a substantial amount of our time living and working in modern cities and they provide exciting and challenging subjects for drawing. At first, the prospect may seem daunting as the number of buildings, their size and degree of architectural detail can lead to visual information overload as thoughts turn to how and where to start. The first thing to decide is what to include and what to leave out. Visual editing is an important part of any picture-making process, but it is even more

important when the proposed subject seems highly involved and complex.

In truth the subject should be assessed in exactly the same way as the simple building drawn in Demonstration 1 (see pages 18–23). The modern cityscape drawn here may look complex at first glance, but on further investigation it is in fact possibly far more straightforward to draw than many individual buildings which shoot off in any number of different directions and are covered in untold amounts of architectural detail and decoration. Modern cities are little more than a series of boxes that vary in shape and size and stand closely next to one another. Externally, the more modern of

these office blocks are covered in row upon row of identical windows which are little more than rectangles, the monotony of which is only relieved by their reflections, which are often of other identical buildings.

The subject may sound Orwellian but in fact this type of cityscape is great fun to draw and although much of the surface detail is linear, the drawings can benefit and are simplified by being made using a medium which is essentially tonal. It is the tone rather than line that is used to describe the deep shadows. These help indicate the shape of the buildings. Tone is also used to indicate the countless windows and the play of light reflected in them.

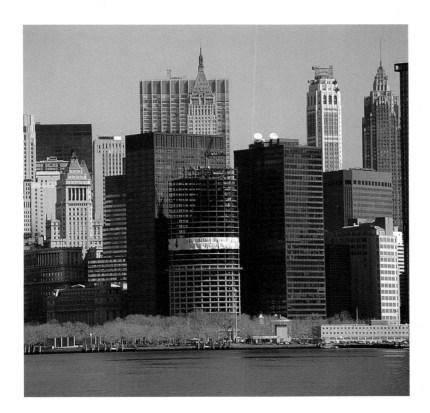

Subject

The overwhelming scale of city buildings and the fact that they are often built in very close proximity to one another can make drawing them challenging. Here a wide river provides a useful open space which enables the artist to distance himself from the subject.

Materials

Hard, medium and soft charcoal pencils

Sheet of white cartridge (drawing) paper 594 x 420mm (23½ x 16½in)

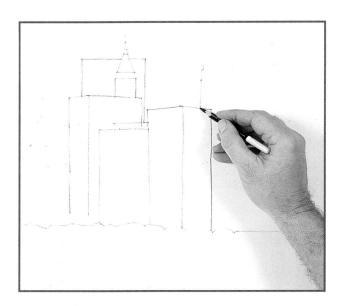

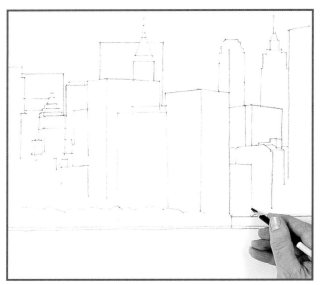

1 Place the central, upright rectangular building in position using a hard charcoal pencil. Measurements can be taken to ascertain the building's correct proportion. Once this building has been correctly positioned draw the surrounding buildings by relating their size and position to it. Draw these in using simple rectangular shapes.

2 Working out from the central group of buildings, draw the rest using the same process of relating one simple shape to the one next to it. Gradually the sky line will begin to appear.

Artist's tip
Prevent smudges when using soft drawing materials by resting your drawing hand on a tissue or piece of paper towel.

3 Once you have positioned the main buildings, draw the rows of windows and floor levels on the central building which is in the process of being erected. You do not need to count each floor but do make sure that enough floors are indicated so that the buildings look their correct size.

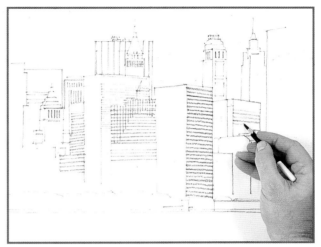

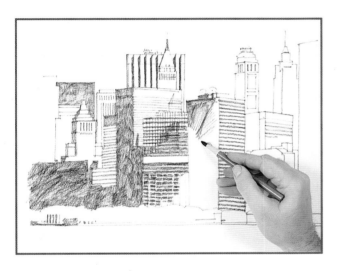

4 Use the medium charcoal pencil to scribble in a dark tone over the side of the buildings which are in deep shadow. This immediately has the effect of adding a sense of space and firmly positions one building in front of another.

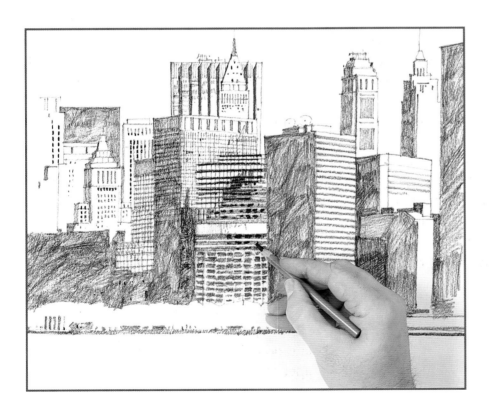

5 Use simple shapes to suggest the dark passages beneath the trees along the river edge. Change to the softest charcoal pencil (which is also the darkest) to draw the very darkest shadows seen deep within and beneath each floor of the building being erected.

6 Draw in row upon row of individual windows using the flattened point of the medium charcoal pencil. As before it is not necessary to count all of the windows but the effect should match what you can see; place in too few and the building will look wrong. Finally, complete the drawing by using the medium pencil to draw in a series of parallel, horizontal lines of tone across the water in the foreground. Indicate a few darker reflections at the water's edge with the darkest pencil.

Artist's tip
Unless intended, make every effort to keep uprights vertical and running parallel with the edge of the support. This is relatively easy when looking at a building from a distance. Close-up the verticals will run away from you at an angle creating the vertical perspective.

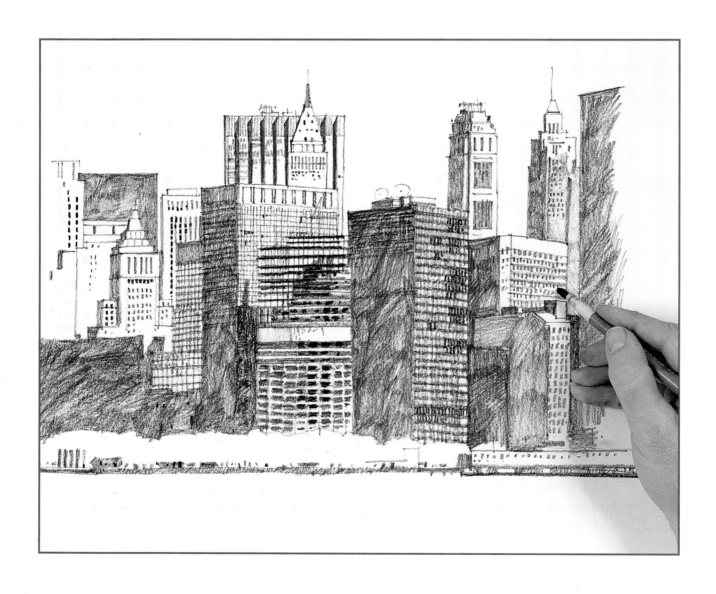

TRY A DIFFERENT ...

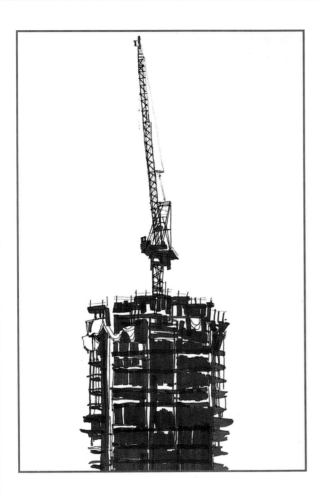

... BUILDING

At close quarters city buildings stretch high above resulting in the need to utilize three-point perspective. Not only will there be a separate vanishing point for both visible sides of the buildings, but there will also be a vanishing point high above the buildings where the converging sides of each structure meet.

... MEDIUM

Here I have focused in on the crane surmounting a new office block building. Plastic sheeting flaps in the breeze and scaffolding can be seen holding up the floors prior to receiving the outer walls. A thick black marker pen and a fine liner are the perfect tools for sketching the dark silhouetted shapes.

Demonstration 6

Using tone *Dip pen and ink*

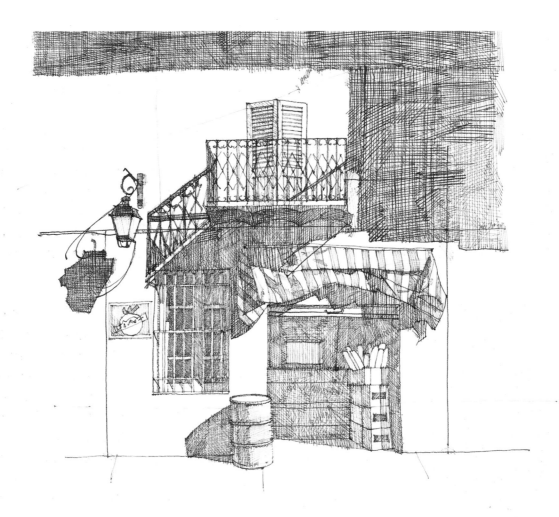

Tone is an important technique and needs to be mastered in order to give depth, dimension and a degree of accuracy to your work. In this respect it is even more important than the use of colour (which we tend to be more aware of). If the distribution of tone is muddled and incorrect the shape of the image will read badly. Obtaining the correct spatial relationship between objects is therefore of primary importance. Many things influence tone including colour and surface texture, but the primary influence comes from the quality and direction of the light source.

A full tonal range consists of hundreds of tones ranging from white to black. You can practise making tone by creating a tonal scale known as an achromatic scale. Try to create eight or ten blocks of tone which vary in depth, beginning with a very light tone and ending with a deep black. There is little point in trying to create hundreds of subtle tones as the eye tends only to recognize a limited number. Using as little as three distinct tones is sufficient to successfully show the shape of something. Try making a scale using several different media and techniques; for example soft scribbled graphite, blended charcoal and hatched pen line. You will find the practise very useful.

It can be difficult to judge tone accurately when drawing. Remember it is easier to make a tone darker than it is to make a tone that is too dark, lighter. Gradually increase or build the tone, erring on the side of lightness and strengthen any darker tones as and when needed. Be careful not to compensate too much or your work will lack contrast and "bite".

When using pen and ink, hatching and cross-hatching provide an effective way of applying tone which, if used with thought, is highly controllable, although time consuming. The slightly mechanical feel can be tempered by keeping the hatching loose and varying the direction of the pen strokes.

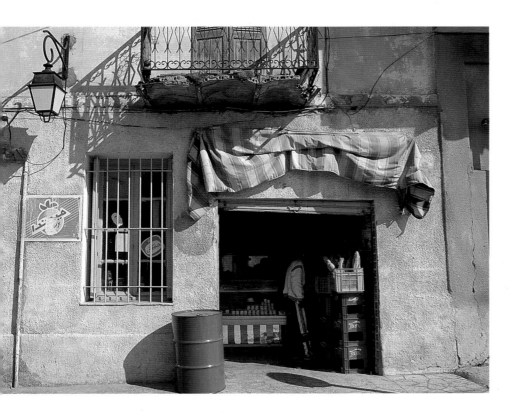

Subject
This shop front is typical of so many found in hot countries. The raking, bright sunlight hitting the concrete and wrought iron balcony throws deep, strong shadows across the front of the building with its cool, dark interior. On first glance the subject might be one of limited appeal, however the almost abstract blocks of deep tone shadow hold the interest.

Materials

Dip pen with medium nib

Black Indian ink

Sheet of white cartridge (drawing) paper 594 x 420mm (23¹/₂ x 16¹/₂in)

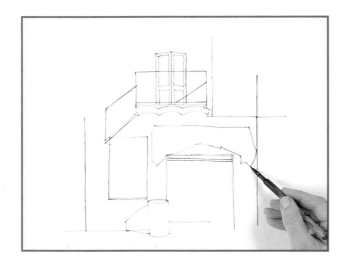

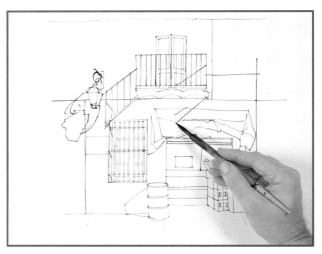

1 Mistakes can be difficult to correct when using ink. If you are unsure, make an initial drawing using pencil and erase it when the work is completed. The drawing can be as elaborate as you like but better results will be obtained if the drawing is not copied slavishly but used simply as a guide. The initial pen work indicates the outline and the position of the main elements. If you are right-handed begin work at the top left-hand corner and work down and across to the bottom right-hand corner (vice-versa if you are left-handed). This will prevent your hand smudging wet ink as it rests on the support.

2 Taking care not to smudge any of the lines that are still wet, work over the image establishing the lamp and its shadow, the basic wrought ironwork on the balcony and the edges and direction of the cast shadows falling across the building's façade. Draw in the boxes and sticks of bread inside the shop.

3 Continuing with line work, complete the bent ironwork on the balcony along with its shadow. The wooden louvres on the shutters, the grill on the lower window and the striped pattern on the scrunched up blind should all be drawn in now.

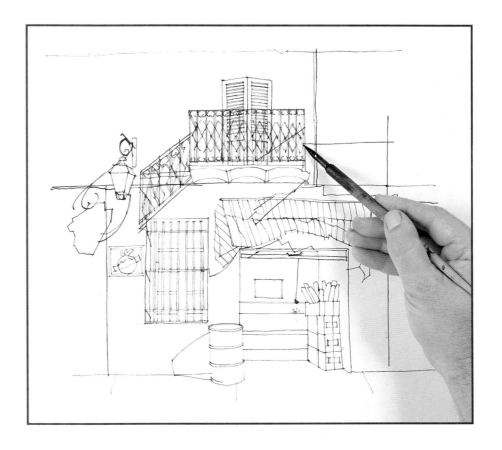

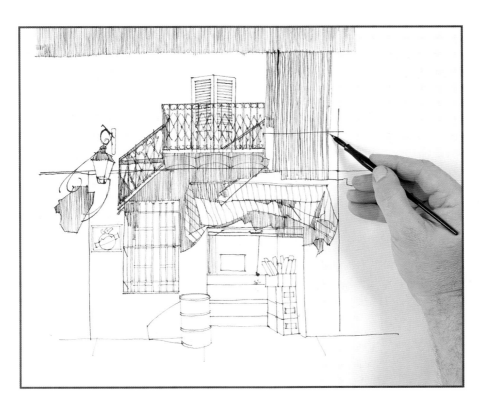

4 Once all of the elements are established, turn your attention to tone. Establish those areas in deep tone using a series of parallel lines. At this stage the result looks monotonous and mechanical, but this will soon alter with the addition of more lines to build the tone which are made to run in varying directions.

5 Take care when working over existing work that it is dry or avoid smudges by not resting your hand on the drawing. Draw in blocks of hatching to build and consolidate the tone. Work these at an angle to the original vertical hatching. Constantly monitor the depth and density of the tone and adapt it by increasing or decreasing the line density.

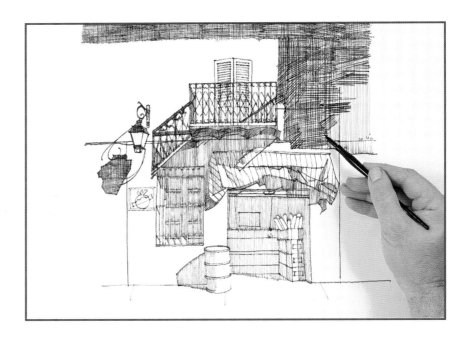

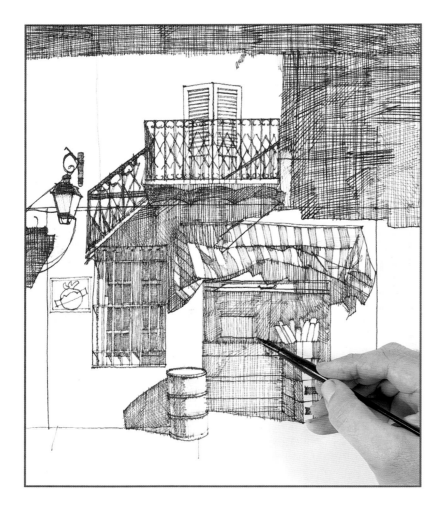

6 Gradually the image is carved from the white support. As you consolidate and strengthen the areas of deep shadow the image begins to have real depth. Give tone to the linear pattern on the blind and use directional hatching on the blind to hint at the direction and fall of the material. Complete the drawing by steadily consolidating existing tone to make it darker and adding light, directional shading onto parts of the blind canopy. This process of careful hatching can be very slow but the results are immensely satisfying as the image finally emerges from the crisp, white support.

TRY A DIFFERENT ...

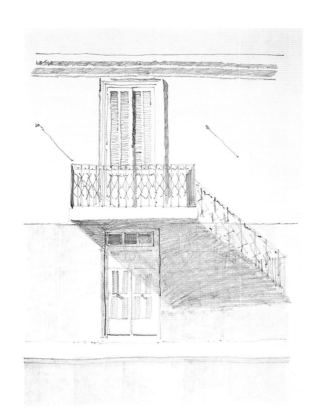

... MEDIUM
This sketch, made using a soft graphite pencil, shows how even a few scribbled flat areas of tone can describe form better than just line work. This technique is well-suited to making rapid sketches whilst on location.

... BUILDING
Whilst this small toy stall in a French park may not possess the stark tonal contrast of the building in the demonstration, it is a subject with a more subtle tonal range with equally deep and dark shadow areas.

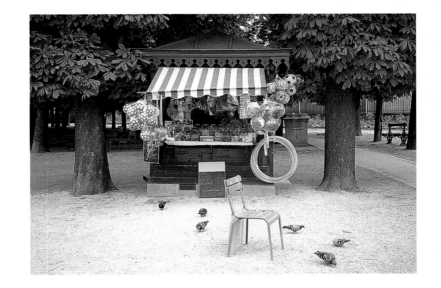

Demonstration 7

Working on a toned ground
Charcoal, conté pencil and chalk

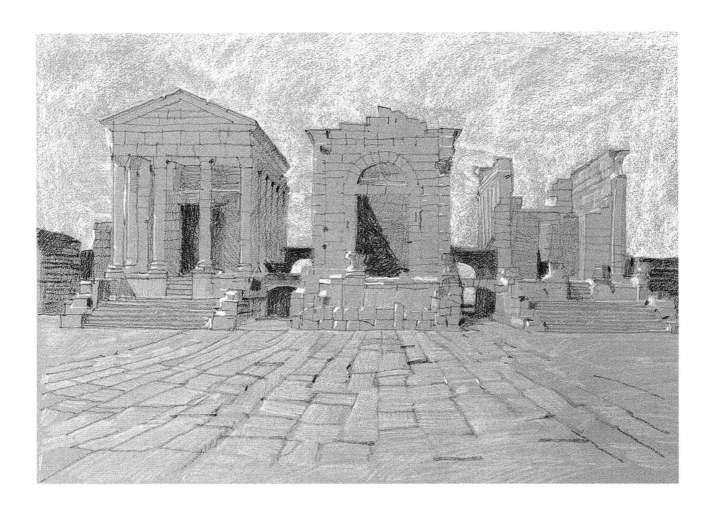

Working on a white support can be, without doubt, intimidating. It can also be less than practical. Establishing large areas of relatively dense tone takes both time and effort but the process is necessary in order to achieve the right balance between the lightest lights and the darkest darks. Balancing these lights and darks and achieving a correct scale of tone is easier if you work onto a toned or tinted ground. The same tone looks very

different when seen against white rather than grey. This can be tested by using your charcoal to make a heavy, dark mark on both a sheet of white paper and a sheet of mid-grey paper. You will notice how the same density of mark seen against the white paper looks much darker than the same mark on the grey paper. The grey paper also allows the use of white, which is both impossible and unnecessary when working off a white support. The technique is a traditional one and works especially well with dusty pigmented materials like chalk, charcoal and conté pencil. The best colour support to choose when using monochromatic black and white is a mid-tone grey. If you do not have a sheet of toned paper it is an easy process to make your own. Simply apply a uniform tone of charcoal or dark chalk to your support, distribute this over the surface using a rag or paper towel and fix.

Solid, heavily textured architectural subjects seem to respond well to this technique as both support and drawing materials seem possessed of certain qualities which ideally suit the subject. Keep in mind when drawing ruined buildings that despite their apparent state of ruin and disrepair, they are still buildings and will conform to the same rules of perspective as a modern office block.

Subject

Architectural ruins offer a wealth of picture-making possibilities. They are invariably in peaceful and pleasant locations and the subject is such that, although certain principles of perspective need to be observed, artistic licence can be freely taken.

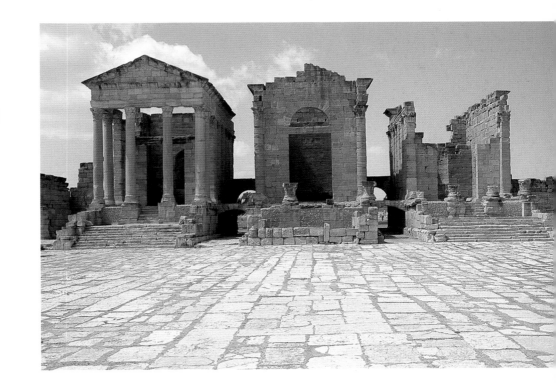

Materials

Soft black charcoal pencil

Soft white conté pencil

Stick of white chalk

Stick of charcoal

Fixative

Sheet of mid-grey pastel paper
380 x 545mm (15 x 21½in)

1 Using the soft, black charcoal pencil position the three main buildings using a series of simple geometric shapes. Position them so that they run across the top half of the drawing. This allows for the large area of ancient paving in the foreground. All three buildings and the paving share a single vanishing point which is positioned loosely on the top step in the middle of the arched doorway of the central building.

2 Once the main buildings have been correctly positioned, begin to add detail. Draw the pillars on the left-hand building first, followed by the steps and a suggestion of the rows of stonework. Draw the arch on the central building next, along with the rows of stonework suggested together with the broken capitals that would have surmounted the no longer existing pillars.

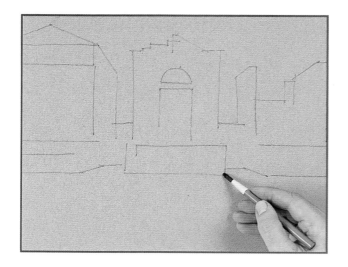

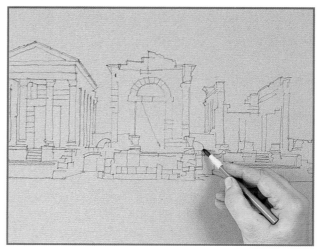

3 Complete the rows of stonework along with the steps leading up to the two outer buildings. Then turn your attention to the somewhat random rows of stone paving slabs that cover the open foreground. These need to be carefully drawn. Although they conform to the rules of perspective they do so loosely as they are all of a different size and tend to meander in the same general direction rather than following a straight line.

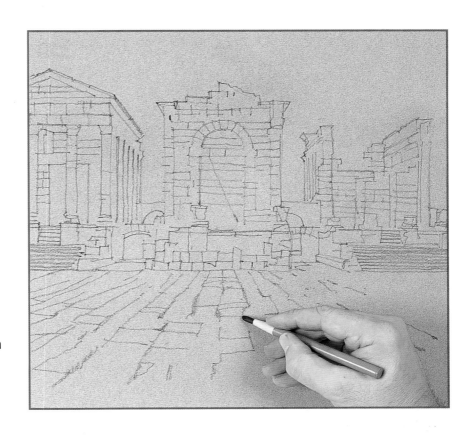

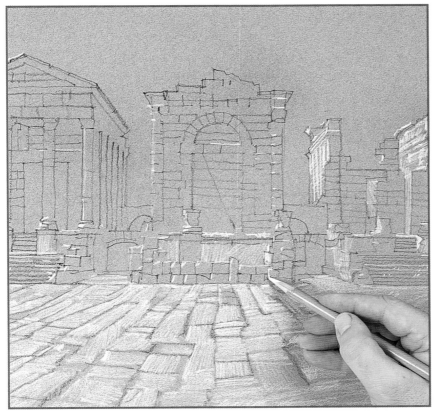

4 Use the white conté pencil to draw in the lighter tones. The sun is shining from the left-hand side so only a few highlights are evident on the left-hand building whose visible parts are mostly in shadow. A few more highlights can be seen on the central building but the position and angle of the right-hand building means that the two side walls are visible in full sun light. The paving is worn smooth by hundreds of years of wear and reflects the sunlight like a mirror.

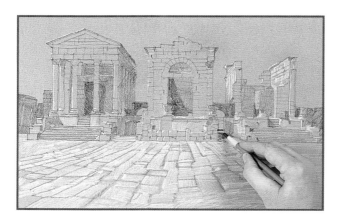

5 Returning to the black charcoal pencil, add the darker areas of tone deep within the shadows. Use two tones – scribble a dark tone over the buildings in shadow, followed by a much deeper, heavier tone for the very dark passages deep within and between the main buildings.

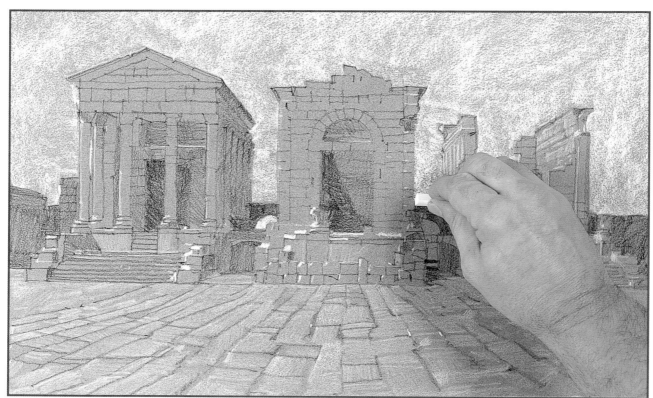

6 The buildings are much darker than the sky; this is easily remedied by using the stick of chalk to put a uniform covering of white over the area of sky. Bring this up to and carefully around the buildings, not forgetting to cover the area seen through the two arches between the main buildings. Complete the drawing by deepening the tone in places and applying a few heavy darker marks using the stick charcoal (this makes a much denser darker mark than the pencil). The finished drawing, although far from laboured, captures the dusty, hot character of the subject with the toned support lending a feeling of solidity which might not have been so evident had the drawing been made on white paper. Apply a coat of fixative.

TRY A DIFFERENT ...

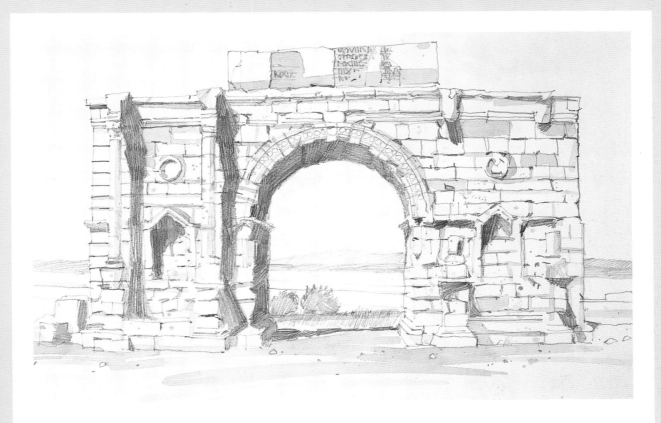

... MEDIUM

A watercolour pencil drawing of a similar subject made on a sheet of white watercolour paper has an altogether lighter feel. The tones are worked up using scribbled and hatched pencil work. These are then worked over using a clean wash of water to soften and blend the tones.

... BUILDING

This imposing building on the banks of the Nile is little more than an oblong box with openings punched into the sides. It is a perfect example of a structure which is all the more remarkable for its understated simplicity.

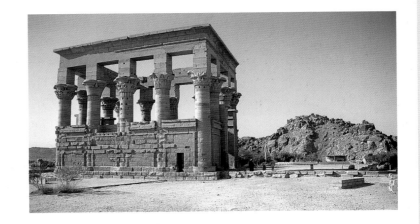

Demonstration 8

Composition
Conté and pastel pencils

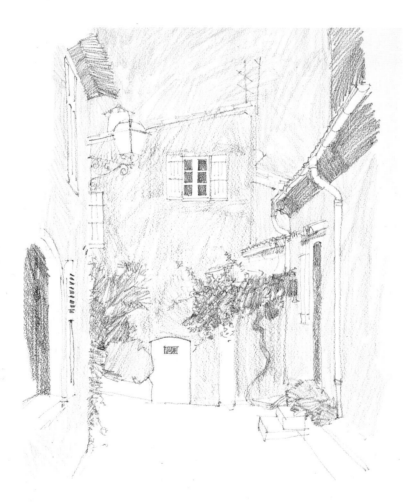

Composition is an important part of all picture-making. Good composition will not make a bad drawing good, but it will make a good drawing better. Composition is about balance and how the eye is led into and around the image. Balance is not to be confused with symmetry. Balance in this context means the pleasing distribution of all of the pictorial elements, which is influenced by a whole range of different factors. Scale, colour, tone, shape and perspective all play an important part in composition although

not necessarily all at the same time. Compositional considerations begin before pencil is laid to paper when choosing a viewpoint. This is when thumbnail drawings should be made. These are simple, small sketches which show the main shapes to be included and give an idea of how the finished drawing might look, how the image is to be cropped and whether the image works best in portrait, landscape or square format. A square format speaks for itself and can be difficult to use; a landscape format is wider than it is high and allows for the eye to travel across and into the image; a portrait format is higher than it is wide and allows the eye to travel in and upwards. It is often the case that the first chosen preferred viewpoint is not the best and that repositioning yourself, sometimes only a few paces in any direction, results in a better composition.

Theories and formulae on composition abound. Two of the most common are the "golden section" and the "rule of thirds" (see pages 14–15). Utilizing either of these can be a good starting point. However, it should be remembered that many great artistic offerings work so well precisely because they bend or even flout compositional rules which result in images possessed of a strength and certain edginess often lacking in safer conservative compositions that rigidly follow all of the rules.

Subject

The confined intimate space within this alleyway dictates a portrait format and a "closed" composition which means that the eye is persuaded to stay within the confines of the picture area by the solid mass of the two buildings on the left- and right-hand side. Similar compositions can be achieved by drawing through an archway, a window or an open door.

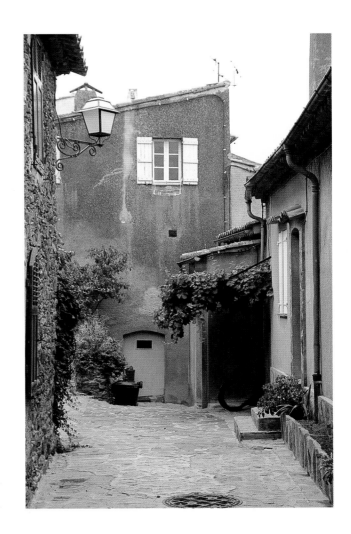

Materials

*Black, terracotta, brown
and ochre conté pencils*

*Light blue, olive green
and sap green pastel pencils*

Fixative

*Sheet of off-white pastel paper
594 x 420mm (23½ x 16½in)*

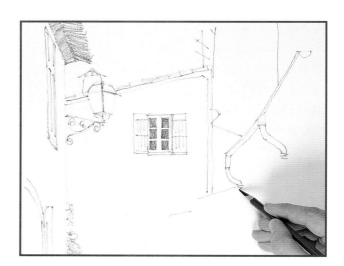

1 Draw the tiles on the building to the left first using the terracotta conté pencil; judge the angle of the roofline carefully. Then use the ochre pencil to draw in the side and base of the building. Again, care should be taken to get the angle at the base correct. The street lamp, the window and shutters and the climbing plant should be established using black.

2 Use terracotta to draw the row of tiles on the end building and the tiles on the chimney. Position the window and shutters and using black work a dark tone over the window openings. Use the same pencil to establish the walls, roof line and guttering on the right.

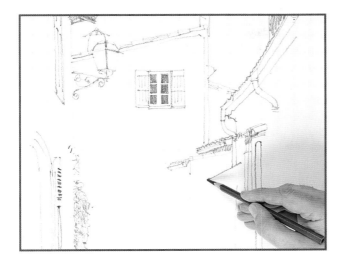

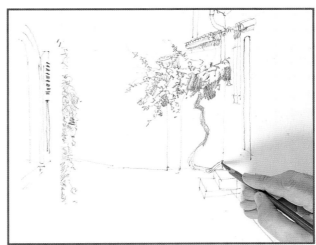

3 Draw in the rows of pantiles over the porch and the row of tiles visible just above the guttering on the right using the brown and terracotta pencils. Using black, give the wall at the top right a dark tone and also the area running beneath the porch guttering in the centre of the image. Draw in the doorway on the right-hand building.

4 Use a combination of black and dark brown conté pencil work to draw in the vine growing from the base of the right-hand building, taking care to carefully draw the old and gnarled twisted trunk.

Artist's tip
When applying a tone or colour do not apply the pigment too heavily. Allowing a little of the support to show through helps to give the image life.

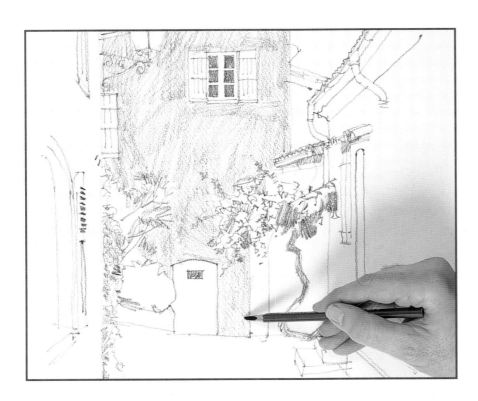

5 Draw the doorway on the facing building and the shape of the bush falling over the low wall on the left. Give the same building a sense of solidity by scribbling on a dark grey tone using the black conté pencil.

6 Use black to also scribble in the deep shadow beneath the guttering on the right and within the window opening on the left. Block in the remaining walls using the ochre conté pencil. Give the drawing a visual lift by adding light blue to the sky and green to the shrubbery at the base of the buildings and the foliage on the vine. Finally, to prevent the image from smudging, apply a coat of fixative.

Artist's tip
When working with highly pigmented and dusty materials that sit on, rather than adhere to, the paper's surface, periodically apply a light layer of fixative to help provide a key for subsequent work.

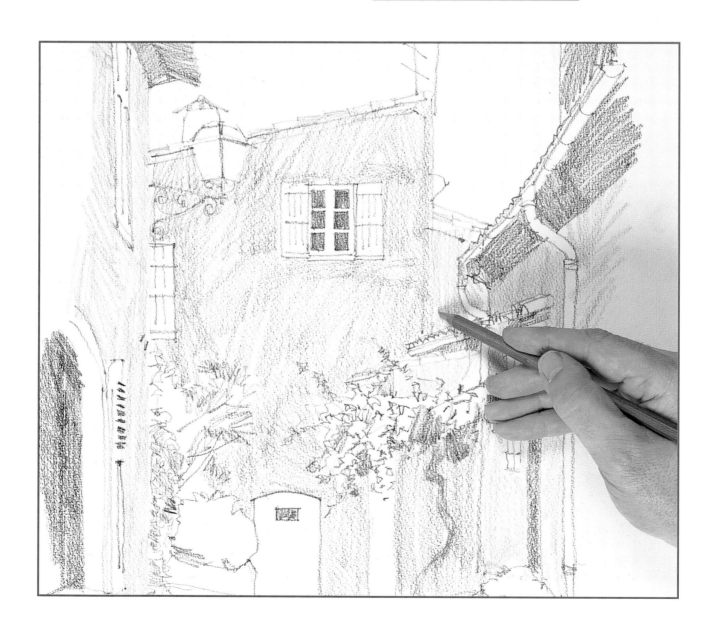

TRY A DIFFERENT ...

... MEDIUM

Here the alleyway is even more confined, with relief being offered by the blast of light visible at the top of the steps. The dark tones possible with soft pencil make it the ideal drawing tool for this type of sketch. Again, the upright portrait format helps to exaggerate the canyon-like effect and the height of the buildings.

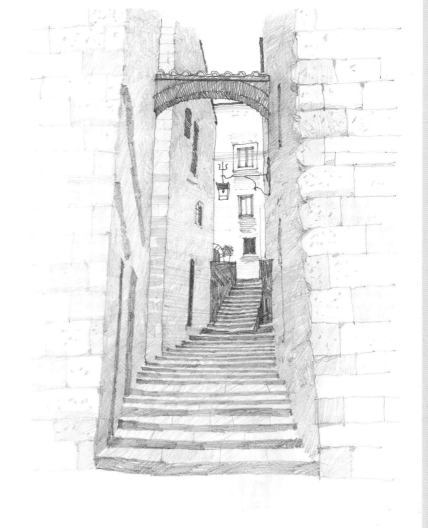

... BUILDING

Here the pathway disappears into a tunnel that leads beneath and upwards through the base of the building. The viewpoint looking upwards and the slight angle of the buildings pose an interesting exercise in perspective.

Demonstration 9

Vernacular architecture
Sketching pen

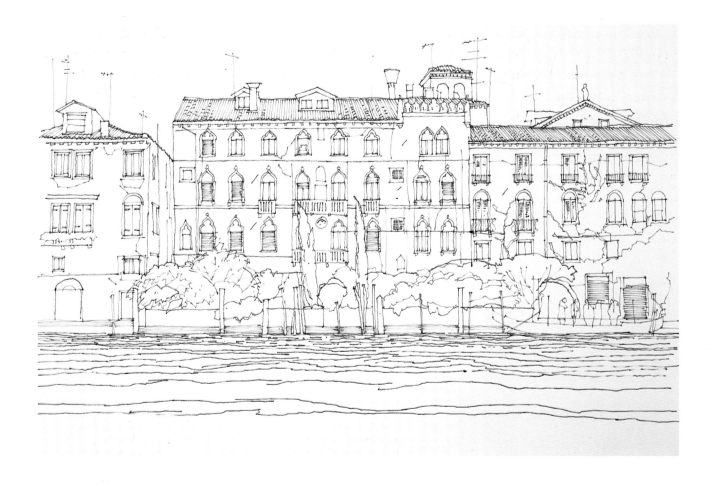

Vernacular architecture is a style of building which is immediately recognizable as belonging to a specific place. This is far less clear cut than it used to be as many of today's new buildings transpose styles sometimes hundreds, if not thousands, of miles away from their place of origin, with eclectic mixes of various styles commonplace in many modern buildings. Originally architectural style grew out of the specific needs of the occupier and the building materials of the area. These needs reflected the climate, social standing and trade of the occupier, whilst the indigenous natural

resources – be they stone, clay or wood – are always the cheapest and most easily exploited building material. Vernacular architecture is almost always immediately recognizable to the knowledgeable, but much of it is also recognizable to the lay person, as in the case of the images used here which could be of nowhere else other than Venice.

When drawing buildings the shape of the building (most are little more than oblong boxes of varying size and proportion) is often of less importance than the correct representation of any architectural details and surface decoration.

Pay particular attention to eccentric roof lines, chimney pots and the shape of doors, windows and window coverings like shutters and blinds. Window shape is especially important as it is in this area that it is possible to spot architects' and designers' main influences. This can be seen in the demonstration subject where the shape of the windows reflects the influence of the Middle East and the Orient, from where many of the original occupants would have earned their fortunes trading.

Including figures, as the artist has done here, helps to give a sense of scale.

Subject

The style and decoration of these buildings betray the influences of the Orient. Many of these buildings acted not only as homes but also as warehouses storing the cornucopia of exotic goods in which the wealthy occupants would have traded.

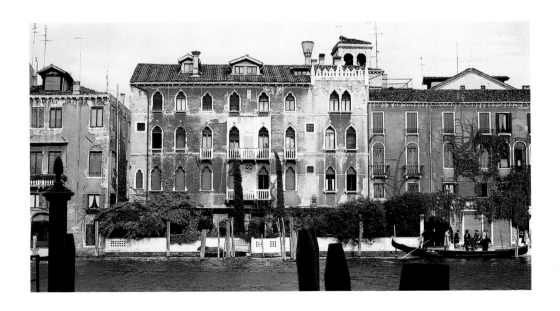

Materials

Sketching pen

Sheet of white cartridge (drawing) paper 594 x 420mm (23½ x 16½in)

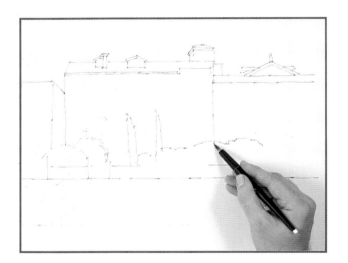

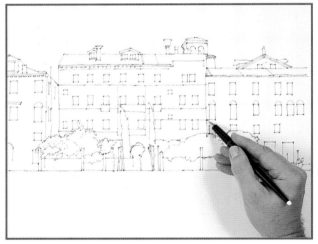

1 If you wish prior to drawing in pen, take measurements to obtain the correct proportions and lightly position the main elements using a soft pencil (remnants of this can be removed with an eraser once the drawing is finished). Using the pen re-draw the main building shapes paying attention to the roof line and the position of the trees and shrubs.

2 Elaborate the trees and shrubbery and draw in the posts used to moor boats at the water's edge. Draw in the rows of windows, ignoring any architectural details at this point, and concentrate on representing them as simple rectangles. It is more important to draw in the correct number of floors than the precise number of windows. No one will count them; if they look right then all is OK.

3 Now draw the window surrounds and arch details. These vary from building to building – some have simple plaster and stone surrounds, while others carry curved elaborate arches with obvious Middle Eastern influences. Draw in the rectangular shape of the balconies and a suggestion of the creeper clinging to the building on the right. Finally draw in the boat and its passengers.

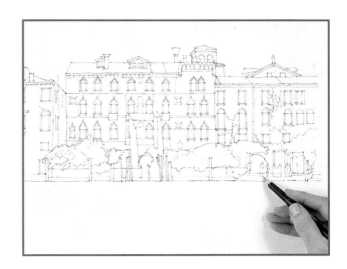

Artist's tip
You can vary the line created from a fixed width sketching pen by varying the speed with which you make the line or mark.

4 Draw in the TV aerials, then begin to elaborate the building façade to show where repairs have been made and the patches of missing plasterwork. Draw in the roof tiles and add balustrading to the stone balconies.

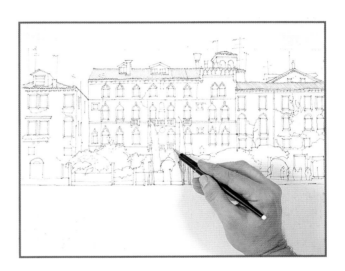

5 Add hinges to the shutters on the far left. Using a series of parallel lines, draw the louvred pull down shutters. Draw the vertical window divides in those windows without lowered shutters and slits in the shutters on the right along with the bent metal balcony surrounds.

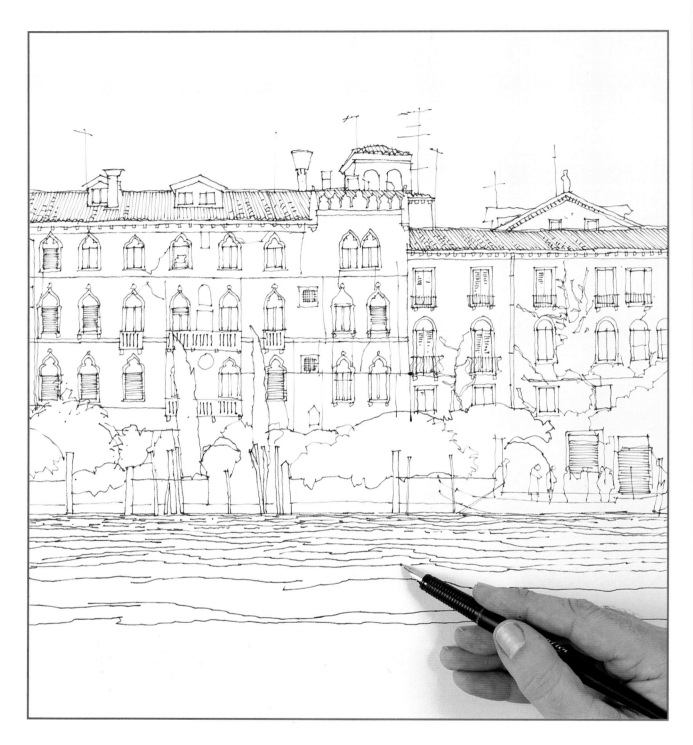

6 Draw a simple series of horizontal wave shaped lines extending from the base of the buildings to the bottom of the drawing. Gradually space them further apart the closer to the bottom of the drawing they get. This helps create the illusion of space, flattening out the water and giving it perspective. Adding branches and elaborating the shrubbery, together with additions to the architectural detailing completes the drawing.

TRY A DIFFERENT ...

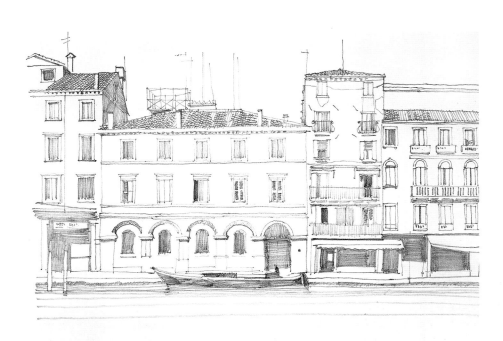

... MEDIUM

In this drawing of a similar subject a 3B graphite pencil replaces the hard dark graphic pen line. The soft graphite is easy and fast to use when sketching and serves as a tool that is capable of expressive line work as well as a range of tones from light grey to darkest black.

... BUILDING

The highly ornate and grand façade of this building will require care if it is to be drawn well as it is a far more complex subject than the demonstration drawing and will not be so forgiving if the correct proportions and window shapes are not established early on.

Demonstration 10

Combining tools and techniques

Graphite and sketching pencils

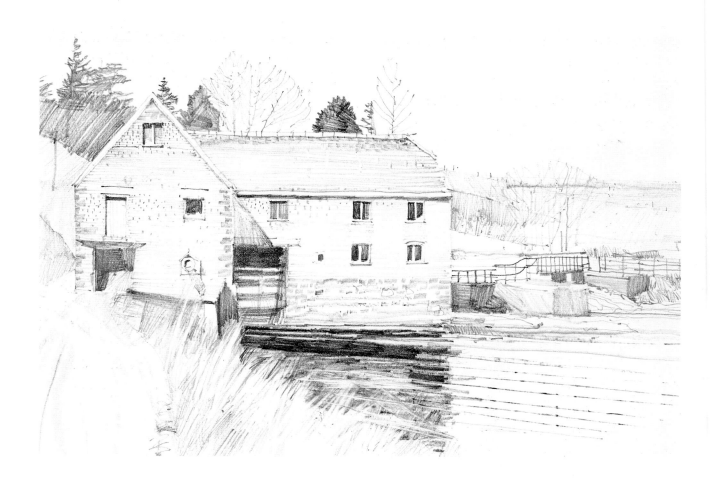

Drawings can be made using the simplest of materials. Indeed when working on location, the simpler the better. Working with just a pencil or a pen in a small sketchbook allows for a certain unobtrusive freedom, which anyone who has struggled on a windswept day in a public place with paper flapping and paint dripping will tell you is highly desirable.

At home or in the studio things are different. Work can proceed at a leisurely pace, the size of the drawing is not an issue and any number of materials and implements can be freely utilized. Materials and techniques are mixed and combined constantly, but care should be taken as it can be overdone. There are some happy marriages including charcoal and chalk and pen and wash, and you should experiment to find those that work well and suit specific subjects. You should also give careful consideration to the surface characteristics of the drawing support.

With practice, a wide variety of marks and effects can be achieved with a single drawing implement, but you will find a more expressive range can be made and utilized if several tools of a similar type but different shape are used. In this demonstration a combination of graphite sticks and blocks has been used. They make a series of distinctive marks with a very different quality from those which could be made using only the traditional pointed "lead" or graphite pencil, but because they are all essentially the same material they blend together seamlessly.

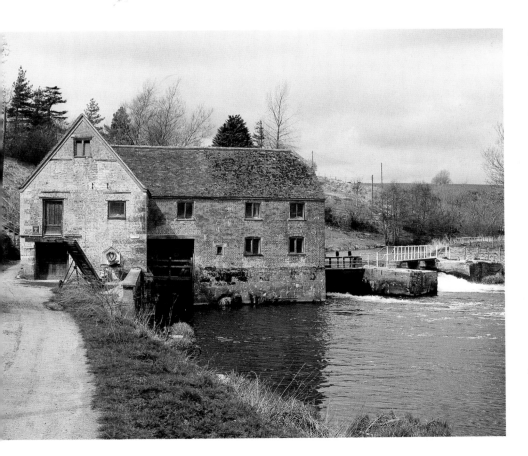

Subject

This water mill is a fine example of a purpose-built work building. Surface textures abound and its position on the banks of a lovely river makes for a pleasant and conducive atmosphere in which to spend several hours drawing.

Materials

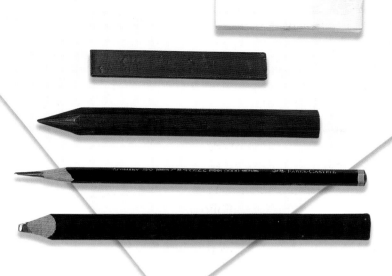

3B graphite pencil

2B graphite stump

4B graphite block

2B chisel-shaped sketching pencil

Hard plastic eraser

Sheet of white cartridge (drawing) paper 594 x 420mm (23½ x 16½in)

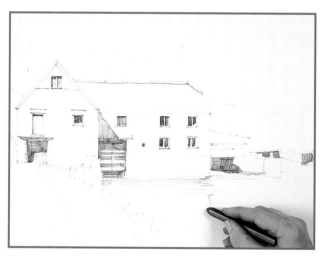

1 Using the 3B graphite pencil, draught out the composition by taking a few measurements to ensure accuracy and the correct proportion. Establish the main building shapes and the major elements in the surrounding landscape. The building is seen "straight on" toward the main front elevation so there is no apparent perspective. The illusion of depth will be provided by the angle of the grass covered riverbank and the wall which stands in front of the building.

2 Use the same graphite pencil to draw in the row of ridge tiles. Add a mid-tone into each window and apply extra pressure to create the darker shadows over this tone. Block in the dark tone seen within the main door and around the opening containing the mill wheel. Change to the 2B graphite stump and establish the shadows on the walls of the weir and across the front of the building above the wheel opening. Draw in the dark reflection of the building in the water.

3 Returning to the 3B graphite stick, draw the lifebelt and its shadow followed by the row of conifers and leafless deciduous trees on top of the hill. Simple line work is sufficient to indicate the safety barrier and grab rails built above the weir. Follow this by elaborating the bushes and trees along the riverbank.

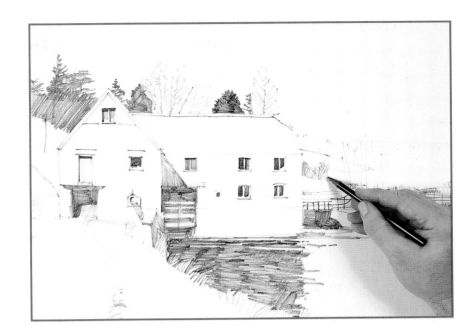

4 Draw in the ruts on the dirt road using the 2B stump. The roof tiles and the brickwork are drawn using the 3B graphite stick. Change to the chisel-shaped sketching pencil and draw the stonework on the gable end building using short, single strokes. Use a similar series of strokes to draw in the stonework around the base of the mill.

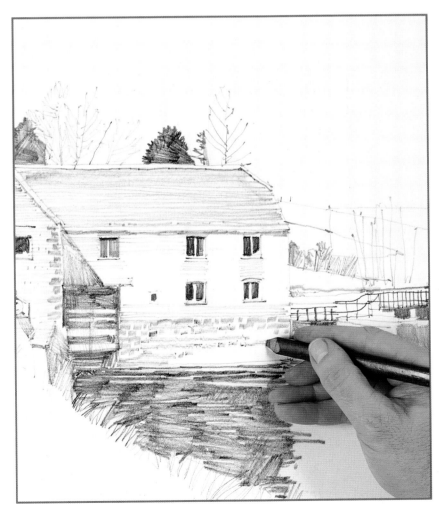

Artist's tip
Maintain the point on thick graphite stumps by resharpening them by rubbing on a piece of sandpaper.

5 Scribble a block of tone over the grassy river bank using the 3B graphite stick. Use directional strokes to depict the fall of the overgrown grass. Draw the ripples across the river using the soft graphite block. Used on edge and pulled across the support, this delivers a thin line that is distinctive and unlike the line made with a graphite stick point.

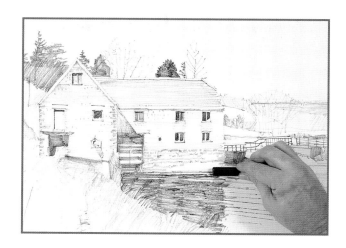

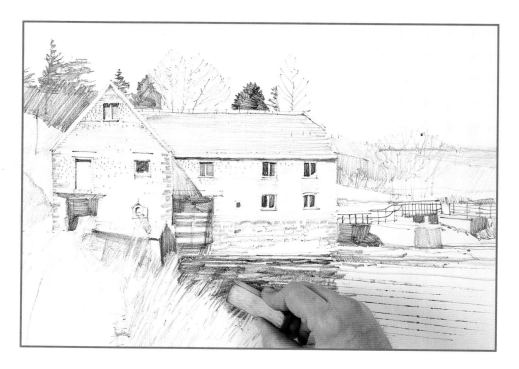

Artist's tip
Before beginning your drawing practise making as wide a range of marks as possible with your drawing implement.

6 One of the beauties of using soft graphite is that it is relatively easy to remove. Not only does this make corrections possible, but it means that areas of work can be worked into using erasers. Textural marks can be obtained in this way which would be otherwise difficult to make. Hard vinyl or plastic erasers are better for crisp marks, whilst softer, putty rubbers are better for knocking back tone over a wider area. Here use a plastic eraser to incise crisp lines into the dark mill reflection to suggest the dried stems of grass. Complete the drawing by redefining some of the roof tiles with marks made using the chisel-shaped sketching pencil. Finally darken parts of the mill reflection using the 3B graphite stick and make a tracery of lines in this dark area using the sharp edge of the plastic eraser.

TRY A DIFFERENT ...

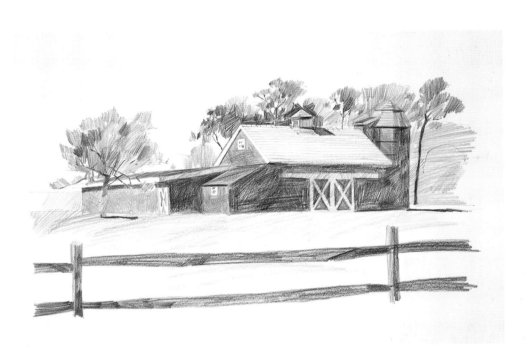

... MEDIUM
The sketch of this red barn was made using pastel pencil. The bright sunlight causes deep shadows and sharp contrast which create an image with a strong sense of depth.

... BUILDING
This tranquil rural scene of a farm building, mill and church provides ample opportunity for combining materials. Try an ink drawing using the variety of marks made possible with steel, bamboo and reed pens. Or try combining two very different materials, such as ink and pastel pencil.

Suppliers

UK

Cass Arts
13 Charing Cross Road
London WC2H 0EP
Tel: (020) 7930 9940
&
220 Kensington High Street
London W8 7RG
Tel: (020) 7937 6506
Website: www.cass-arts.co.uk
Art supplies and materials

L Cornelissen & Son Ltd
105 Great Russell Street
London WC1B 3RY
Tel: (020) 7636 1045
&
1a Hercules Street
London N7 6AT
Tel: (020) 7281 8870
General art supplies

Cowling and Wilcox Ltd
26-28 Broadwick Street
London W1V 1FG
Tel: (020) 7734 9556
Website: www.cowlingandwilcox.com
General art supplies

Daler-Rowney Art Store
12 Percy Street
Tottenham Court Road
London W1T 1DN
Tel: (020) 7636 8241
Painting and drawing materials

Daler-Rowney Ltd
PO Box 10
Southern Industrial Estate
Bracknell
Berkshire RG12 8ST
Tel: (01344) 424621
Website: www.daler-rowney.com
Painting and drawing materials
Phone for nearest retailer

T N Lawrence & Son Ltd
208 Portland Road
Hove BN3 5QT
Shop tel: (01273) 260280
Order line: (01273) 260260
Website: www.lawrence.co.uk
Wide range of art materials
Mail order brochure available

John Mathieson & Co
48 Frederick Street
Edinburgh EH2 1HG
Tel: (0131) 225 6798
General art supplies and gallery

Russell & Chapple Ltd
68 Drury Lane
London WC2B 5SP
Tel: (020) 7836 7521
Art supplies

The Two Rivers Paper Company
Pitt Mill
Roadwater
Watchet
Somerset TA23 0QS
Tel: (01984) 641028
Hand-crafted papers and board

Winsor & Newton Ltd
Whitefriars Avenue
Wealdstone
Harrow
Middlesex HA3 5RH
Tel: (020) 8424 3200
Website: www.winsornewton.com
Painting and drawing materials
Phone for nearest retailer

SOUTH AFRICA

CAPE TOWN
Artes
3 Aylesbury Street
Bellville 7530
Tel: (021) 957 4525
Fax: (021) 957 4507

GEORGE
Art, Crafts and Hobbies
72 Hibernia Street
George 6529
Tel/fax: (044) 874 1337

PORT ELIZABETH
Bowker Arts and Crafts
52 4th Avenue
Newton Park
Port Elizabeth 6001
Tel: (041) 365 2487
Fax: (041) 365 5306

JOHANNESBURG
Art Shop
140ª Victoria Avenue
Benoni West 1503
Tel/fax: (011) 421 1030

East Rand Mall Stationery and Art
Shop 140
East Rand Mall 1459
Tel: (011) 823 1688
Fax: (011) 823 3283

PIETERMARITZBURG
Art, Stock and Barrel
Shop 44, Parklane Centre
12 Commercial Road
Pietermaritzburg 3201
Tel: (033) 342 1026
Fax: (033) 342 1025

DURBAN
Pen and Art
Shop 148, The Pavillion
Westville 3630
Tel: (031) 265 0250
Fax: (031) 265 0251

BLOEMFONTEIN
L&P Stationery and Art
141 Zastron Street
Westdene
Bloemfontein 9301
Tel: (051) 430 1085
Fax: (051) 430 4102

PRETORIA
Centurion Kuns
Shop 45, Eldoraigne Shopping Mall
Saxby Road
Eldoraigne 0157
Tel/fax: (012) 654 0449

AUSTRALIA

NSW

Eckersley's Art, Crafts and Imagination
93 York St
SYDNEY NSW 2000
Tel: (02) 9299 4151
Fax: (02) 9290 1169

Eckersley's Art, Crafts and Imagination
88 Walker St
NORTH SYDNEY NSW 2060
Tel: (02) 9957 5678
Fax: (02) 9957 5685

Eckersley's Art, Crafts and Imagination
21 Atchinson St
ST LEONARDS NSW 2065
Tel: (02) 9439 4944
Fax: (02) 9906 1632

Eckersley's Art, Crafts and Imagination
2-8 Phillip St
PARRAMATTA NSW 2150
Tel: (02) 9893 9191 or
1800 227 116 (toll free number)
Fax: (02) 9893 9550

Eckersley's Art, Crafts and Imagination
51 Parry St
NEWCASTLE NSW 2300
Tel: (02) 4929 3423 or
1800 045 631 (toll free number)
Fax: (02) 4929 6901

VIC

Eckersley's Art, Crafts and Imagination
97 Franklin St
MELBOURNE VIC 3000
Tel: (03) 9663 6799
Fax: (03) 9663 6721

Eckersley's Art, Crafts and Imagination
116-126 Commercial Rd
PRAHRAN VIC 3181
Tel: (03) 9510 1418 or
1800 808 033 (toll free number)
Fax: (03) 9510 5127

SA

Eckersley's Art, Crafts and Imagination
21-27 Frome St
ADELAIDE SA 5000
Tel: (08) 8223 4155 or
1800 809 266 (toll free number)
Fax: (08) 8232 1879

QLD

Eckersley's Art, Crafts and Imagination
91-93 Edward St
BRISBANE QLD 4000
Tel: (07) 3221 4866 or
1800 807 569 (toll free number)
Fax: (07) 3221 8907

NT

Jackson's Drawing Supplies Pty Ltd
7 Parap Place
PARAP NT 0820
Tel: (08) 8981 2779
Fax: (08) 8981 2017

WA

Jackson's Drawing Supplies Pty Ltd
24 Queen St
BUSSELTON WA 6280
Tel/Fax: (08) 9754 2188

Jackson's Drawing Supplies Pty Ltd
Westgate Mall, Point St
FREEMANTLE WA 6160
Tel: (08) 9335 5062
Fax: (08) 9433 3512

Jackson's Drawing Supplies Pty Ltd
108 Beaufort St
NORTHBRIDGE WA 6003
Tel: (08) 9328 8880
Fax: (08) 9328 6238

Jackson's Drawing Supplies Pty Ltd
Shop 14, Shafto Lane
876-878 Hay St
PERTH WA 6000
Tel: (08) 9321 8707

Jackson's Drawing Supplies Pty Ltd
103 Rokeby Rd
SUBIACO WA 6008
Tel: (08) 9381 2700

NEW ZEALAND

AUCKLAND

The French Art Shop
33 Ponsonby Road
Ponsonby
Tel: (09) 376 0610
Fax: (09) 376 0602

Takapuna Art Supplies Ltd
18 Northcote Road
Takapuna
Tel/Fax: (09) 489 7213

Gordon Harris Art Supplies
4 Gillies Ave
Newmarket
Tel: (09) 520 4466
Fax: (09) 520 0880
&
31 Symonds St
Auckland Central
Tel: (09) 377 9992

Studio Art Supplies
81 Parnell Rise
Parnell
Tel: (09) 377 0302
Fax: (09) 377 7657

WELLINGTON

Affordable Art
10 McLean Street
Paraparaumu Beach
Tel/Fax: (04) 902 9900

Littlejohns Art & Graphic Supplies
170 Victoria Street
Tel: (04) 385 2099
Fax: (04) 385 2090

G. Websters & Co. Ltd
44 Manners Street
Tel: (04) 384 2134
Fax: (04) 384 2968

CHRISTCHURCH

Brush & Palette Artists Supplies Ltd
50 Lichfield Street
Christchurch
Tel/Fax: (03) 366 3088

Fine Art Papers
200 Madras Street
Tel: (03) 379 4410
Fax: (03) 379 4443

DUNEDIN

Art Zone
57 Hanover St
Tel/Fax: (03) 477 0211
Website: www.art-zone.co.nz

Index